As someone whose wife has Alzheimer's, I am profoundly grateful for Fran's compelling account of Bob's life, including their last years together struggling with an insidious disease. In her rendering, the human traits of delight and despair are on full display.

**J. Andrew Dearman**
**Professor of Old Testament**
**Fuller Theological Seminary**

My nickname for Dr. Bob Shelton was Dumbledore, because I knew he was the closest I would ever come to knowing that wise, compassionate and fearless wizard. My secret nickname for Fran was Wonder Woman, because she has always known that only love can truly save the world. In my work with them, in my friendship with them, I have come to know real-life superheroes.

**Camilla Ballard, Youth Director**
**First Presbyterian Church**
**Dallas, Texas**

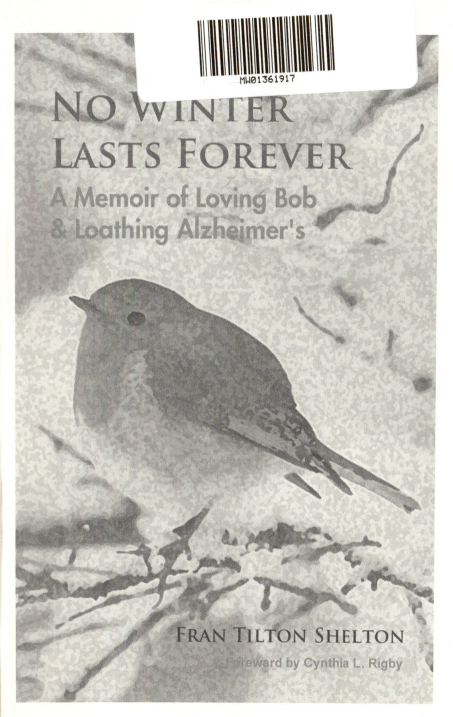

# No Winter Lasts Forever
## A Memoir of Loving Bob & Loathing Alzheimer's

© 2019 Fran Tilton Shelton

www.FranTiltonShelton.com

Published by Adriel Publishing

FIRST EDITION

ALL RIGHTS RESERVED. No part of this book may be reproduced in any form or by any means whatsoever, including photography, xerography, broadcast, transmission, translation into any language, or recording, without permission in writing from the publisher. Reviewers may quote brief passages in critical articles or reviews.

Printed in the U.S.A.

Cover design by Elizabeth Lawless & Fran Tilton Shelton

ISBN: 978-1-892324-50-4

Library of Congress Number 2019913485

# Endorsements

As my minister in Mays Landing, N.J. many, n[any] years ago, Rev. Bob Shelton taught me a little about baseball, a little bit about basketball, a[nd] quite a lot about how to be a good person. Fra[n's] memoir captures the complexities of living with [a] person with Alzheimer's, but, even mor[e] importantly to me, also presents the essence of this remarkable man.

**Jack McCallum**
**Sports Illustrated Writer and**
**New York Times Best-selling Author**

This book is a must read for all who seek to find guidance, compassion, and comfort in the face of Alzheimer's. Fran's writing is real, raw, honest and inspiring, and seeks to bring dignity to those who fight this horrible disease, as well as wisdom and hope to those who walk with them.

**The Rev. Holly Hoppe, Co-Pastor,**
**Grace Presbyterian Church**
**Pflugerville, Texas**

# DEDICATION

This book is dedicated to Mary Rixford, M.A., LPC,
who helped me through the winter.

# ACKNOWLEDGEMENTS

Virtual hugs of thanks to:

**First, my family.**

**Sharon Hampton Balch**—for your friendship, for keeping confidences, for your endearing relationship with Bob who always said, "You two make a great team."

**The Reverend Brian Hardesty-Crouch**—for your spiritual direction, your silence, your prayers.

**Jack McCallum**—for loving Bob, for your books ("*Dream Team,*" "*Unfinished Business*" and others) that provided Bob and me hours of entertainment, for reading rough drafts, suggesting I use contractions, fewer adjectives, and zero to few exclamation points!

**Kathryn Moore**—for inviting me to an Andrea Bocelli concert that included his compact disc, *Sì*, that background music for my palette of emotions.

**Connie Webb**—for saying, "Come on, Fran, think about keeping the alliteration going. What about loathing instead of detesting?"

**Last, my family**—Margie H. G. Allen; Sarah, Ken, Kaya and Stax Coward; Alice and Dean Duerksen, Margaret, Leo, Ethan and Sam de Luna; Omi, Robert, Isabella and Trey Ford; Tammy and Rich Mackesey; Diane and Jim Shelton and Natalie Borg.

# Hal Borland
## A Promise

*No winter lasts forever, no spring skips its turn.*

*Sundial of the Seasons* (1964)
Series of New York Times Editorials

# Table Of Contents

| | |
|---|---|
| Foreword by Cynthia L. Rigby | 11 |
| Chapter 1: The Diagnosis | 17 |
| Chapter 2: Secrets: How To Handle | 21 |
| Chapter 3: Working Through The Shock | 27 |
| Chapter 4: Worries | 33 |
| Chapter 5: Onward | 39 |
| Chapter 6: A Preface On How We Met | 45 |
| Chapter 7: Chapel Goers | 51 |
| Chapter 8: You Say Kubutz; I Say Kibitz | 57 |
| Chapter 9: Called To Serve | 65 |
| Chapter 10: Crazy | 73 |
| Chapter 11: Seminary Worries | 81 |
| Chapter 12: Turning Point | 89 |
| Chapter 13: Help Us Accept Each Other | 99 |
| Chapter 14: Getting To The Truth | 115 |
| Chapter 15: I'm By Your Side | 121 |
| Chapter 16: Estes Park | 129 |
| Chapter 17: Descent | 135 |

| | |
|---|---|
| Chapter 18: Getting Help | 141 |
| Chapter 19: Getting Lost | 147 |
| Chapter 20: Friday | 157 |
| Chapter 21: Saturday | 165 |
| Chapter 22: Sunday | 175 |
| Chapter 23: Things Will Never Be The Same | 181 |
| Chapter 24: First Wedding Without Bob | 185 |
| Chapter 25: Good News Bad News | 189 |
| Chapter 26: Ashes | 193 |
| Chapter 27: Words, Books & Bridge | 201 |
| Chapter 28: A 17-Month Year | 211 |
| Book Club Questions | 215 |
| Author Bio | 221 |
| No Spring Skips Its Turn Book 2 | 222 |

# Foreward
## By Cynthia L. Rigby

I first met Bob on the evening of February 1, 1995, when he picked me up at the old Austin airport. I had come to interview for a faculty position in theology at Austin Seminary. Born, bred, and educated in the northeast, I was having a little trouble picturing myself living in Texas. When Dean Shelton (a.k.a. "Bob") arrived at the airport dressed in blue jeans and running shoes, he didn't come across like any other academic I knew. As he drove me to the seminary condo, he talked with a long, slow drawl about the weather (he was sorry it was so cold) and the schedule for the next morning. A faculty member named John would pick me up at 7 am; Bob hoped I was OK with migas for breakfast. "Sure!" I responded, as enthusiastically as I dared. Bob eyed me with amusement. I'm sure he could tell I had no idea what migas were.

The next day, at my interview, I met another Bob. Intelligent and quick; cunning and good humored; I could barely keep up with his questions and challenges. "Are you evangelical?" he asked me, not letting me off the hook when I responded with, "it depends on how you define it." "Are you a feminist?" "Again, it depends on what you mean . . ." And then, leaning back in his chair: "Tell me. . . would you rather be *boring* or *wrong*?" Bob grilled me until I got aggravated and fought back, which, I found out later, sold him on me as a good hire. I always appreciated that about Bob—he wanted those around him to be as smart and determined as he was, even if he disagreed with them.

Before coming to Austin, I had heard a lot of stories about Bob from my friend Scott Black Johnston. One of my favorites was about Bob and Fran. They had gotten engaged, and Bob wanted to surprise faculty members and administrative colleagues with the good news. He didn't know how to type, so he wrote the announcement out by hand. He waited in his office until everyone had gone home for the day, then figured out how to use the photocopy machine to make duplicates. Finally, he slid a copy under each colleagues' door,

imagining what their reactions would be when they found it. The next day he stayed away from the office so he wouldn't have to answer any questions!

This book is a love story: the story of Bob and Fran. But it is also a story of how love stories are shaped by faith, struggle, and service.

"People grieve the way they live," Fran Shelton wisely writes. And the story she tells in the pages that follow shows how she and Bob grieved, and lived, together. A commitment to vocation obviously stood at the center of their relationship. When they were beginning to see each other and didn't want to be separated, Fran was called away to a ministry position and they endured the distance between them. When they were called to devote themselves to each other in marriage and Bob got caught up in planning the most logical timeline, Fran said (more or less!), "no way are we waiting — if this is what we're doing, we're doing it now." When Bob was called to the tasks of presenting at the Presbyterian Historical Society and doing a eulogy at his sister Kathy's funeral even as his Alzheimer's was rapidly advancing, Fran sat by his side, painstakingly helping him retrieve ideas and sentences, piecing

them together with him into a coherent whole. This is what I picture when I think of Bob and Fran's love story—the grief they had to have felt in the long anxious hours this took, every hard-won sentence reminding them that things were not as before. And yet they did it until it was impossible to do anymore. Why? Because they loved each other, sure. But even more because they were committed to helping each other follow God's call with everything they had left; to "marching forth" together into something greater than themselves in which we all participate—at least in this world—for but a fleeting, precious moment.

The greatest contribution Bob made to my life was insisting I live and work in faithful submission to whatever God was calling me to do. He got me to Austin Seminary, and then continued nudging me toward my call even when I was unsure, unqualified, or just plain unaware of what I could accomplish. Because he knew I was called, he championed me—a young woman who had not completed her Ph.D. and was still under care—to teach every incoming student theology. Because he believed I was called, he insisted I accept the students' invitation to preside at Baccalaureate early on, when I was not yet ordained. "The

community of faith has requested you do this, so we must find a way," he said. And then there was the time I called Bob at 6:30 am on the morning of the Spring Board of Trustees meeting, convinced that I was about to be fired because I had not yet finished my dissertation. "Thank goodness!" he said, "I thought you were calling to tell me you were taking another job!" I laughed with relief and he continued, "Now get back to work—we have a big day ahead."

In all the years we worked together, there was only one time Bob gave me a serious scolding. Readers who knew him and those who read this book, won't be surprised. It was my first or second year at Austin Seminary and I had just led a chapel service in what is now *Shelton* chapel with the communion table pushed over to the side. Bob made a beeline for me at the end of the service.

"Sorry, Bob! It was that way when I came in —I just didn't notice," I said, lamely.

"You *have to* notice," he said, staring me straight in the eyes as though we were the only two in the chapel, even though there were people milling all around us. "Remember, Cindy: What we are doing here is not a show. It is not about us.

It is about God and God's gracious invitation. If the Table gets in our way — good. It should."

I will remember, Bob. I will remember, Fran. I will aim to remember so well that, even when I am bogged down by grief about my inadequacies, I will continue marching forth, trusting in the sufficiency of God's grace and leaning on the witness of all the saints who have persevered.

Thanks for the blessing of your lives, you two. And for this book, Fran, which will help us remember and be renewed in what we're all about.

# CHAPTER 1
# The Diagnosis

******

*Alzheimer's disease
starts when a protein that should be folded up
properly misfolds into a kind of demented origami.*

**Gregory Petsko**

******

**The patient is a pleasant 77-year-old married, right-handed, Caucasian male who was presented for his outpatient neuropsychological evaluation accompanied by his wife.**
K. D., Ph.D.

The first time I read the above introductory fragment to Bob's neuropsych evaluation was the last day of August 2012. I read it through a tsunami

of tears that unleashed anger, fear and sadness. Today when I read the words, tears, fresh and faithful as morning dew, still pool up to buoy unanswered questions and an awareness of my naiveté in thinking sadness could not grow into a pervasive state.

I was outraged that my husband would be described in such a clinical style. Thoughts bounced in all directions across my mental map— Hell yes, he is pleasant! He is also charming, wise, and best and most of all he is my lover, a supportive father, and a doting grandfather. Holy shit!

All these years we'd been so grateful that Bob's cardiologists didn't believe that surgery, like placement of coronary stents, was required. Should we have sought a second medical opinion that may have recommended surgery to enable more oxygen to get to his brain? And what the hell difference does it make that he is right-handed?

I sat at attention earlier that afternoon as the doctor reticently shared the results of Bob's neurological test results. We were stunned and chilled with disbelief. Finally, I pieced together some words, "All this time, I thought Bob became overly anxious and *that's* what caused him to

forget what he wanted to say." The doctor politely informed me that I had gotten it *bass-ackwards* (my words) and explained, "He's not able to remember words and facts because of the Alzheimer's and vascular dementia and that makes him anxious."

Toward the end of our appointment, the doctor had the audacity to say, "Dr. Shelton, it would be helpful for you to exercise more." That is when I took on the persona of Mr. Bumble in Charles Dickens' *Oliver Twist* and roared, "MORE?!" She nodded affirmatively and I launched into a monologue that our courtship and early marriage included three-mile daily runs. Now, 18 years later, we continue to walk that far every day. Furthermore, in inclement weather, Bob walks on our treadmill for an hour—on Level 7 for a distance of four miles. Exercise more?! Bob was visibly embarrassed by my outburst so I squeezed his hand hoping for some forgiveness.

As I punched "*1" in the elevator, memory punched through my emotions. In the mid-90's, while serving as an associate pastor at New Braunfels Presbyterian Church, I had read *The 36-Hour Day: A Family Guide for Caring for People Who Have Alzheimer's* by Nancy L. Mace, M.A. and Peter V. Rabin, M.D. MPH (now in its 6$^{th}$ printing) in

order to better comprehend what members of my flock were living through. I had visited them in their homes, listened to their stories of anguish and adjustments and watched them weep.

The seminal research of Mace and Rabin accurately describes *"The 36-Hour Day"* with no holds barred and had left stark images of *"demented proteins"* embossed on my heart. These raised and sunken images resurfaced and pointed to what our future may be holding.

# CHAPTER 2
# Secrets: How To Handle

\*\*\*\*\*\*

*The costs of keeping secrets include our growing isolation due to fear of detection and the ways we shut down inside to avoid feeling the effects of our behavior. We can never afford to be truly seen and known even by ourselves.*

**Sharon Salzberg**

\*\*\*\*\*\*

On our way home from the neurologist's office, Bob suddenly broke our silence: "I don't want to tell Tammy and Jim (his children) about this diagnosis." He expanded the circles of silence

to include their spouses, Rich and Diane, as well as other family members and friends. I agreed to honor and respect his request, although I disagreed and believed that it would add an additional weight and difficulty to coping with our grief.

Another, albeit lesser, dose of reality hit me when we got home. The next day I was scheduled to begin, of all things, a new, part-time job as spiritual director at a pastoral center. I was in seventh heaven to begin such a practice. The past three years I'd participated in HeartPaths DFW, a training program in the art of spiritual direction, a practice of daily spiritual disciplines and holy listening. The program had been an answer to my 2008-year-long prayer for discernment, "Gracious and loving God, how may I offer the gifts you have given me to the glory of Christ *and* have more time to spend with my family?"

Now my soul-conversation was, "God, *seriously*, how am I going to go to work tomorrow?" All I *wanted* to do was to run crying to the director of the pastoral center and scream, "My husband has just been diagnosed with Alzheimer's and vascular dementia." I wanted to quit before I even started. I wanted to spend every living, breathing moment with Bob.

As an associate pastor for congregational care, I regularly facilitated grief workshops, spoke to civic and church groups about the grief process, and met with bereaved individuals and families. I also officiated at many memorial services—so many that Bob started calling me, *"Funeral Fran."* With this focus in ministry, I chose to attend a day-long conference on grief for part of my continuing education.

The only piece I remember from that day is quite possibly *the most helpful information* I have ever learned about persons in the grief process. This is where I want you to imagine a drum roll—

### People grieve the way they live.

The class's complete silence indicated to the facilitator a need for explanation. As illustrations were presented, we realized it was a simple and yet profound concept in understanding individuals in the grief process. I don't recall the illustrations given; however, the one below is about Bob.

One hundred percent of people surveyed would say that Bob was an introvert, a workaholic, an aficionado of baseball, an appreciator of single-malt Scotch, and a bona fide fan of Willie Nelson.

Consequently, after the 1980 death of Barbara, his wife, he went to work earlier, stayed later, and made a stop at Austin City Limits before finding his way home. During the World Series, he would drag his over-sized box of a television to work so that he could watch the games in between teaching classes, meeting with faculty and students, and while working after closing time.

The conference presenter had emphasized that as long as men, women and children were grieving the way they lived day-to-day (perhaps with more intensity) friends and caring professionals needed only to lend additional support and encouragement. It's when persons do quite the opposite that there's cause for concern.

Hence, if Bob had shouted from Reunion Tower in downtown Dallas that he had been diagnosed with Alzheimer's, ceased going to work (yes, he still worked!), refused a double old-fashion tumbler of Macallan with one cube of ice, didn't listen to Willie or enjoy baseball, *then* there would be concerns about his ability to cope.

When I asked myself, "How do I live? How do I grieve?" the answers had been provided by my younger daughter, Sarah. Sometimes it takes a child to speak the truth in love and tell us who we

are. The two of us were at a Church event and several people kept asking her, "How does your mother handle this workload? How can she do all that she does?" I honestly wanted to know for myself, so I moved closer to hear what she had to say. In her honest and easy fashion, "Oh, my mom cries a lot, laughs a lot and goes to bed early!"

Truer words were never spoken. Recalling Sarah's description of me, I recognized that I needed a safe place to cry a lot and to process my other emotions. I had agreed not to be totally honest or forthcoming to our family about Bob's diagnosis. I was determined, however, to be so with him.

"I'm going to make an appointment with Mary Rixford. Would you like to go with me?"

Bob said, "I'd like to talk with Bill (his beloved, long-term family medical specialist) and see what he has to say." Our sanctuaries were identified and appointments were made.

# CHAPTER 3
# Working Through The Shock

******

*There is only one kind of shock worse than the totally unexpected: the expected for which one has refused to prepare.*

**Mary Renault**

******

In late 2011, Bob first voiced his concerns about his lack of agility in recalling words, names of friends, crossword puzzle answers and directions to some of our favorite haunts. His concerns intensified after Dr. Jim Currie, a treasured friend, invited Bob to write a history of The Cumberland Presbyterian Church (CPC) and to present his work at the Presbyterian Historical

Society of the Southwest's meeting in May 2012. It was a history that Bob knew well. Not only was he a CPC minister, he was also the son of a CPC minister, a brother-in-law to two CPC ministers, and a former moderator of the denomination. Additionally, he served as an adjunct professor at Memphis Theological Seminary (affiliated with the CPC), and at the time of diagnosis was serving on the board of trustees.

Bundled up for our winter evening walks, Bob talked about possible angles and approaches he was considering for this project. He was eager to do as close to exceptional work as was possible because for generations he held high regard for each branch of the Currie family tree. He was enthusiastic when he shared that he had decided to entitle the paper, *"Cumberland Windows"* and use the metaphor to open sub-topic *"windows."*

On each turn in our neighborhood walk, Bob stressed that he needed my help in typing his hand-written rough draft and on each turn, I assured him that I would be more than happy to help. Not only did I want to support him, I'd long wished to learn some CPC history because all I knew was that the CPC was the first Presbyterian branch to ordain a woman, Louisa Mariah Layman

Woosley, and that I was married to one of its pastors.

I wasn't able to type Bob's drafts right away because I was already stretched beyond my bandwidth. February 12 was going to be my last day as associate pastor at Preston Hollow Presbyterian Church (PHPC) where I had served close to a decade. On several occasions, I'd delayed resigning because when I would imagine myself crawling up into the pulpit for the last time and looking out at all "my" beloved PHPC flock sheep and lambs, I would emotionally fall apart. I was smitten with the members; I didn't like the schedule. Yet now, with Bob approaching 78 years young, I felt the time was overdue. My mantra to Bob became, "Let me get to February 13 and baby, I'm all yours!"

That day came and Bob handed me his work. The yellow legal pad was filled with a mixture of beautifully cohesive sentences along with garbled fragments of sentences written, crossed out, re-written, crossed out, and re-re-written. His work reminded me of the movie, "*A Beautiful Mind,*" particularly the chalkboard scene where Russell Crowe, playing the mathematical genius, John Forbes Nash, Jr., had scribbled

equation after equation that made little to no sense. To borrow from President Franklin D. Roosevelt, February 13, 2012, became for me *"A Date Which Will Live in Infamy."*

Panic square-danced throughout my nervous system. I circled *left* and asked Bob if he was willing to call Jim Currie and regretfully decline the invitation to write the CPC history. "Absolutely not!" he vehemently replied. I circled *right* and slowly began deciphering some of the more clearly written fragments he had written. We did a *do-si-do* and I promised him that we would somehow, someway get the paper written.

I sensed a need to model calm and confidence so that Bob would feel the same way. I teased him and said that we would pretend we were college-age lovers pulling all-nighters to complete an assignment. We sat side by side at the dining room table where with each glance of him and exchange of soft kisses, I was charged with motivation to help him.

As always, we had many things going for us. Bob, in his heart of hearts, knew his subject. And when he was calm and sitting by me, he could dictate his thoughts to me as I typed. Excellent resources were in our personal library and *Google*

was available to fill in some blanks. Best of all, Bob's niece and her husband, Susan and Matthew Gore, are history buffs and serve as archivists for the CPC denomination. I called and asked them if they would be willing to read, revise, and proof each *"Window."*

"Of course!" they said.

Through this experience, I considered compiling and submitting prayers (morning, midday and evening!) for *A Book of Uncommon Prayers*. They would solely consist of gratitude for computer features like: *copy, cut, paste, delete, save, save as, attach, and open.* Needless to say, my wish to learn more about the CPC was granted. More importantly, our prayers were granted as God, Susan and Matthew helped us complete the project. When the final period was in place, Bob and I sang *The Doxology*, went to bed and made love.

# CHAPTER 4
# Worries

\*\*\*\*\*\*

WORRYING
*does not empty*
**TOMORROW**
OF ITS
**TROUBLES**
\*\*\*
IT EMPTIES
**TODAY**
*of its*
**STRENGTH**

Mary Englebreight

\*\*\*\*\*\*

Worries and stress were not over, however. Bob still had to present his paper at the annual meeting that was being held in Denton, Texas. I was not able to attend because the year before I'd agreed to lead a women's retreat scheduled the same weekend.

Although Bob had diligently worked on his presentation by memorizing salient features of *"Cumberland Windows,"* I worried that the disease would cause him to get flustered and he would forget all that he had memorized. Yes, I remembered that the doctor said it was the other way around! I worried about his safety in driving to Denton. I worried whether or not he would be able to find the motel where the historical society was meeting.

Months earlier I had preached a sermon, *Do Not Worry* based on Matthew 6:25-34. I attempted to quell my worries by remembering some of the key points I'd made. For example, Ecclesiastes 3:2-8 gives a litany of 28 acceptable ways time is spent (including a time to kill and a time for war) yet *WORRY* is not once listed.

After the sermon and before giving the congregation God's blessing, I charged them to not worry by whistling Bobby McFerin's 1988 hit,

*Don't Worry, Be Happy.* Now, as I was waving good-bye to Bob and heading off to the women's retreat, McFerin's tune was sounding like a scratchy record or a three-fold amen in my heart, soul, and mind, "Don't Worry, DON'T worry, DON'T WORRY."

Thanks be to God, Bob made it to Denton and found the hotel. And with additional thanks to God, the speaker before him went overtime, leaving Bob with only five minutes to present. When I asked how he had done, he gave his hallmark reply, "Better than I deserve!" His Calvinist background was rooted in the knowledge that as children of God we are continuously blessed by grace upon grace.

But I continued to worry. I would have bizarre thoughts wondering if Alzheimer's was contagious—through the sensual movements of a kiss? If so, bring it on because I was not going to quit kissing Bob! What if it was the Diet Coke—he drank one to three each day? If so, too late. I would still pour one in his glass sans ice, the way he liked it. What if it was coffee? Or something as crazy as watching Mark Shields and David Brooks each Friday at 6 p.m. on the Public Broadcast System?

Worries pushed back and responsibilities behind us, we began to talk and question about what might possibly be in front of us. Bob was eager to learn options available to him. I shared that while serving in congregations, I had learned that there was medication that had the potential of stopping or slowing memory loss; however, most individuals were too damn scared to go through the necessary testing. He immediately said, "I am not afraid. Will you schedule the tests for me?" Witnessing Bob's courage, gave me a measure of similar courage.

My internist gave me the contact information for the best resource in Dallas. Requests for neurological testing have increased exponentially so we had to wait a month before an appointment was available. We went together for the initial meeting with the neurologist—somewhat like a meet and greet. The next step was for Bob to take a battery of tests lasting about four hours. Test day came and Bob wanted to drive himself to the doctor's office.

When he returned, we went for our daily walk. He was upset that they had asked him to name as many vegetables as he could and he had produced a very short list. I was shocked.

Listening to his anguish, I became sympathetic and defensive on his behalf. To lighten his mood, we began talking about his utter lack of cooking expertise. He was reared on a farm in southern Illinois where he and his brothers helped their Dad in the field and with the animals.

His frustration mounted over his inability to recall vegetables and I did not help the situation by asking, "Couldn't you have just thought through the alphabet and said asparagus, beans, carrots and so forth?" With that he laughed and said, "Well if they had asked me something I **know** like theologians, I could have easily rattled off — Augustine, Barth, and Calvin." Case made!

Other quiz questions included spelling five-letter words backwards and starting at 100 and counting back by seven's. For several weeks we were diligent in tackling words like, R-E-T-A-W, S-S-A-R-G, S-U-I-R-P (I drive one) and O-V-L-O-V (Bob's 2000 model of wheels) but the exercises began to suck the joy out of our time together. With knowledge of this neurological exercise, I quit counting sheep in order to fall asleep and I began to do the math — 93, 86, 79, 72, etc.

The most troubling aspect to Bob was the questions about suicidal thoughts. His honest reply

of "Yes" prompted additional questioning as well as a short break so that the test administrator could seek another professional to question Bob. As conversations went deeper, Bob shared his belief, "Anyone with an ounce of intelligence has thought about suicide." He also assured them that he had *no* plan *or* intentions to take his life by suicide. He wanted to live. He was visibly upset by the commotion that his beliefs had caused and he apologized profusely to the psychologists. When Bob and I went to learn results of the testing, he began the conversation with more apologies about the disruption caused by his suicide comments.

# CHAPTER 5
# Onward

\*\*\*\*\*\*

*You can only learn so much from books.*
*You can only learn so much from education.*
*Ultimately, it is the wisdom of God that will carry*
*you through in the toughest situations of life.*

**Ravi Zacharias**

\*\*\*\*\*\*

Thankfully, the diagnosis did not initially change our daily schedules. I'm not sure if we were in denial or simply determined to carry on as before. Bob made the coffee every morning, loaded and unloaded the dishwasher, mowed the yard and continued to drive to work several days a week. We enjoyed our walks and Bob would often

remark on the beauty of the sky, the neighbor's landscape and the opening of our red hibiscus. With a blend of remorse and gratitude, he would remark, "Before, I was always too busy to notice these things." I still laughed, cried and went to bed early. We did hold each other longer and more tenderly, usually falling asleep spooned in our double bed.

When my sleep was disturbed by thoughts of the future, I engaged in the spiritual practice of breath prayers. Snuggled next to Bob, I inhaled *Light of the World* and exhaled *Show me the way.* The side benefit of night-time breath prayers is that eventually one unknowingly falls asleep. One night, I was jolted awake hearing these divine words from the deep recesses of my soul: *"We will run this race with perseverance looking to Jesus the pioneer and perfecter of our faith."* I was washed with relief, gratitude and hope. Then I pushed back, "But God you do know this is not a sprint. Alzheimer's is a marathon!" Still this holy assurance gave me comfort.

Since I didn't grow up participating in Bible Sword Drills, the next morning I looked up the verse and saw that it was not word for word; however, I discovered that the passage from

Hebrews promised me even more support on this new journey of ours.

> *"Therefore, since we are surrounded by such a great cloud of witnesses, let us throw off everything that hinders and the sin that so easily entangles. And let us run with perseverance the race marked out for us, fixing our eyes on Jesus, the pioneer and perfecter of faith. For the joy set before him he endured the cross, scorning its shame, and sat down at the right hand of the throne of God. Consider him who endured such opposition from sinners, so that you will not grow weary and lose heart."*
>
> Hebrews 12:1-3

It took some time to get an appointment with one renowned neuropsychiatrists in Dallas. Bob immediately connected with her. He especially appreciated her directness. And for the same reason, I was less than enthused. We sat watching her across her desk as she read in a clinical, robotic manner from Bob's file something like, the spouse

refused permission for patient to have an MRI. Looking up from Bob's chart and staring at me, she asked, "Why's that?"

I sat silently while my inner dialogue pled, "May the defense have a moment for explanation?" While serving in congregational care, I'd developed a love/hate relationship with the majority of the medical profession. While I appreciated their expertise, I grew frustrated with what I considered needless and expensive tests.

Hence, I asked, "What good would an MRI do? What changes would it bring?"

"It would help us to determine if your husband has a brain tumor. If not that, it could indicate that he may need to take two aspirins a day rather than one," she said.

"Oh my God," I thought, "I don't need to be reported to adult protective services **or** begin this journey known as the bad wife."

"Schedule the MRI," I said.

And what a fiasco that was. Bob was both overly nervous and compliant. The medical attendant assured us that the MRI would not take long. The clock's downward and then upward sweep of the second hand let me know that an hour had passed. I was worn out with breath

prayers and had never known they could lead to hyper-ventilation.

I watched three white coats sail pell-mell through the waiting room and I got scared. Had Bob had a heart attack? Had he run screaming out the back door and was on the loose? Why didn't someone come tell me what the hell was going on? More time elapsed.

Finally, I couldn't take it anymore and decided to get to the bottom of things. Just as I stood up, Bob walked out with the technician. Relief! Hugs! The technician apologized for the delay and explained that the machine had broken down mid-way through the test. He went on to say that Bob had been a real trouper. As Bob and I headed to the car, he said, "I never have liked computers."

The upshot: Bob did *not* have a tumor and he continued to take *one* aspirin per day.

# I Could Write a Book
## By Rodgers and Hart

*If they ask me, I could write a book
About the way you walk and whisper and look*

*I could write a preface on how we met
So the world would never forget*

*And the simple secret of the plot
Is just to tell them that I love you, a lot*

*Then the world discovers as my book ends
How to make two lovers of friends*

# Chapter 6
# A Preface On How We Met

******

*Each meeting occurs at the precise moment for which it was meant. Usually, when it will have the greatest impact on our lives.*

**Nadia Scrieva**

******

The first sentence I recall him saying was, "After my first heart attack I made a list of ten things I wanted to do if I was lucky enough to survive." Silence and nervous laughter co-mingled from the small group of entering seminarians in August, 1990.

"What was on your list?" a student asked.

The Academic Dean, leading this orientation session for a delayed-in-traffic professor, slid down

with ease into the chair, removed his half glasses extending them to the class in an invitational manner, and with his left hand rubbed his bearded chin.

"Well," he said in a Tennessee drawl that prompted greater curiosity, "I wanted to grow a beard, buy a Miata, and retire to Montana."

Amid much laughter, another student asked, "What were the other seven?"

Quickly sitting up, leaning toward the class, scanning the group with his scintillating blue eyes, he said, "Ohhh, I can't share those in public!"

There, in a flash of minutes, Austin Presbyterian Theological Seminary (APTS) Dean Robert M. Shelton, captivated the students, or at least me, with his charm, quick wit and dreams. He completely dissipated any and all anxieties entering students possessed.

Newbies were filled with anxieties, doubts, and fears about embarking on studies of theology, Hebrew, church history, and Old Testament, meeting classmates, and sharing personal call stories that seemed in real time to be clear evidence of the Holy Spirit at work. These stories, describing calls to ministry, were written so clearly on each individual heart. Many had quit jobs, packed up

families and pets, and rented U-Hauls in the hellish August heat to move to Austin, Texas.

After Dean Shelton's calming introduction, our round of personal stories began, and to me at least, some sounded dubious. I mean who would *not* hear a call from God in order to quit working the midnight shift scooping cookie dough on baking trays for the Keebler Elf?

And *how* could a Southern Baptist, Baylor University graduate hear a call to become an Episcopalian priest? As the Baptist was seeking the telephone number for the Episcopal Seminary of the Southwest, the chatty telephone operator (keep in mind this was 1990) shared that there was another seminary in Austin, as well. "Would you like that number, too?" asked the operator. There on the line, the inquirer heard a call to change denominations and choice of seminaries.

Then there's the story that wound up a bit boring and flat. It was about a church secretary who was typing confirmation lessons and when she glanced out the window onto a dirty, downtown alley, she suddenly felt like a disciple who dropped his fishing net and began to follow Jesus…a portion of *my* story.

After listening to the first round of call stories (there would be many more), I asked Dean Shelton, "Earlier you mentioned that after your **first** heart attack you made a list of things you wanted to do. Does that mean that you have had other attacks? "

"Yes," he said, "I had one in 1985 and then one this past April. I'm relieved that my doctor said I didn't need surgery. I watch what I eat. I run a couple of miles every day except Wednesdays—everybody needs one day off. When we have a bit more time, I'll tell you an interesting story about President Stotts and my recent heart attack."

It didn't take much cajoling from the class before Dean Shelton began sharing. The gist of the story was that Stotts arrived in Austin to begin his term as the seventh president of APTS only to learn that his academic dean and long-time colleague was in the hospital recuperating from a heart attack. As soon as possible, Stotts went to check on his dean. After friendly exchanges, Stotts picked up a brochure on the bed side table describing a cardiac catheterization. Shelton said, "I tried to downplay that I was scheduled for a heart cath the next morning. I didn't want to think about it and I certainly didn't want him to worry about it."

Stotts began describing a man's experience with such a procedure and the lawsuit that was filed. It seems that the medication given to the man prior to the procedure immobilized his arms and legs, leaving him unable to move, speak, or even bat an eyelid. It *did not,* however, keep him from feeling the intense pain and pressure from the procedure. "Yet," Stotts continued, "he wasn't able to let the doctors know because the medicine left him immobile." Stotts kept giving more graphic details of the event until Shelton interrupted, "Jack, now I understand why you are a professor of ethics and not pastoral care."

# CHAPTER 7
# Chapel Goers

******

*Worship is a way of seeing the world in the light of God.*

**Abraham Joshua Herschel**

******

Worship attendance at APTS was not required because heaven forbid, that would seem too legalistic for Presbyterians. Rather, a warm invitation to participate in daily chapel service was extended to all entering students. Orientation groups enthusiastically made their way up the hill to take a seat in the pews much like young lambs jumping into a new verdant pasture. My enthusiasm took a dive into the deep recesses of

heartache when I saw that the first reading was Psalm 139 which has always been inextricably bound to my Dad. A senior student began reading:

*"O LORD, thou hast searched me and known*
*me.*
*You know when I sit down and when I rise up;*
*you discern my thoughts from far away.*
*You search out my path and my lying down,*
*and are acquainted with all my ways.*
*Even before a word is on my tongue, O LORD,*
*you know it completely.*
*You hem me in, behind and before, and lay*
*your hand upon me.*
*Such knowledge is too wonderful for me; it*
*is so high that I cannot attain it.*
*Where can I go from your spirit?*
*Or where can I flee from thy presence?*
*If I ascend to heaven, you are there!*
*If I make my bed in Sheol, you are there!*
*If I take the wings of the morning*
*and settle at the farthest limits of the sea,*
*Even there thy hand shall lead me,*
*and your right hand shall hold me fast.*
*If I say, "Surely the darkness shall cover me,*
*and the light around me become night,"*

*Even the darkness is not dark to you,*
*the night is bright as the day;*
*for darkness is as light with thee."*

Psalm 139: 1-12

During the reading, I went back to being a kindergartener sitting in my dad's lap listening as he read the Sunday newspaper comics to me. I saw the ochre smudges between his right index and middle fingers evidence of his addiction, beginning as a teenager, to a pack-or-more-a-day of Camel cigarettes. I was so happy that he was home and sober.

It is grace, it is love, it is incredible that in the amount of time for the second hymn to pipe through the organ, I was transported from sitting in a chapel pew in 1990 to standing next to my dad who was nervously reclined on a hospital bed the evening of November 18, 1987.

None of our family had been surprised when my dad was diagnosed with lung cancer. We were saddened and pissed. I learned early on not to say "pissed" in front of my dad. He believed that such language revealed a limited vocabulary and suggested I use an alternative like *"sorely*

*vexed."* Okay, so out of respect for my dad, I was sorely vexed with the diagnosis mainly because he had been sober for five years. He was working. He was fun to be around. Five years—the longest stretch of sobriety in the 32 years of my life. Sorely vexed is putting it mildly!

My dad's surgery coincided with the Great American Smokeout Day, November 19. He quipped, "I'm going to observe the day by having a lung out."

My mom and I gave half-hearted laughs. Laughter is our family's primary coping tool and we hoped that the laughter sounded like hope, confidence, and assurance that all was going to be well. The doctor had told us, "Removing a portion of a lung is an easy, fairly routine procedure."

The next morning, in pre-dawn darkness, my mom, sister and I drove to the hospital. Daddy looked so vulnerable. He was sitting up wearing the standard wrinkly hospital gown. His hands were inter-locked behind his neck making his arms look like open wings or like he was ready to begin doing sit-ups. It was his poor attempt at nonchalance that none of us really felt. Each of us was doing the best one can in that tension between hope against hope and utter terror. As the nurses

came to roll him away, my dad handed me his watch, and I gratefully put it on, thereby keeping a piece of him with me.

My dad died within hours of the *"fairly routine procedure."* Psalm 139 was read at his graveside worship service two days later. Now, almost three years later, looking down at his watch that I continued to wear, I felt my dad was with me. He was in this very chapel. He was as close to me as my breath and his presence gave me assurance that he, a pre-Vatican II Roman Catholic, was giving me his blessing to embark on this spiritual and academic journey at a Presbyterian (USA) seminary.

I began a one-way conversation with him by telling him that when he died, I whispered to God, "I am so thankful my dad did not die drunk. I am thankful that I did not want my dad to die." There had been plenty of times in my life when I did want him to die (it is complicated living with an alcoholic). I thanked my dad profusely for his sage advice that gave me a strong sense of his approval for me to initiate a divorce. Over and over again, I shared how grateful I was for his holy and spiritual presence with me on this new journey.

As I walked out of chapel, I noticed Dean Shelton sitting on the back row, pulpit side. Soon I learned that was *"his spot"* and that he was one of the administrators and faculty members who were known as *"chapel goers."*

I thought everyone would *want* to be a *"chapel goer."* Who wouldn't want to meet God in the beauty of the sunlight beaming through the stained glass windows that spotlighted the vast number of dust particles; to meet God by the stately concrete pillars on the lectern side adorned with symbols of the major prophets, or by the pulpit side columns with symbols the four gospels; to meet God by looking at the shields of the disciples carved in wood serving as reminders of the great cloud of witnesses surrounding us on our earthly pilgrimages?

## Chapter 8
## You Say Kubutz; I Say Kibitz

******

*Bridge is such a sensational game that I wouldn't mind being in jail if I had three cellmates who were decent players and who were willing to keep the game going 24 hours a day.*

**Warren Buffett**

******

Seminary life was all consuming. I was busy learning new words like eschatology, parousia, and pericope; completing work at my on-campus job as *"Xerox Queen"*; and staying aware of my kiddos' elementary school homework; therefore, it was a month later before I again encountered Dean Shelton. He was speaking on behalf of the

seminary at a celebration for Laura Lewis, professor of Christian Education, who had completed work for a Ph.D from the University of Texas. I watched him transform from a nonchalant, stooped-shouldered, in-dire-need-of-a-haircut academician to an energized speaker who elaborated on Laura with wit and wisdom.

After he spoke, I turned to Alice Underwood, a classmate, and said, "If (BIG IF) I ever got married again, I would want my husband to be like him."

Where upon Alice said, "He's not married. His wife died from breast cancer about ten years ago."

I knew the thought of imagining I could find a duplicate of such an intelligent, thoughtful, and funny man was ludicrous. I took small pleasure, however, in knowing that at least an example of such a man did exist.

Greater pleasure than fantasizing about a future relationship was completing my first semester of seminary. When home-town friends asked how I did regarding grades, I responded, "Well I made all Bs in seminary and we (my older daughter, Omi and I) made all As in fifth grade!"

Omi's teacher, Becky Browning, was, without a doubt, *THE* most amazing, talented, and demanding of high expectations teacher I have ever known. In the fall of the school year, she was diagnosed with breast cancer. She also demanded high expectations of herself; therefore, after a very brief absence she returned to the classroom holding her bald head high, speaking openly about cancer, and endearing each and every student and parent to her.

Needless to say, it had been a tough move and semester of adjustment for each member of my family: Omi, 11; Sarah, 6; and me, a 35-year old, second career student. We were glad to see the calendar turn to January, 1991 and rejoiced that we had made it.

One required seminary Jan-term class was an intense, all day, four-week study of Hebrew, a course that put the fear of YHWH (a tetragrammaton in Hebrew for God) in the veins of every student. That was particularly true for me, who had taken nominal Spanish in high school and, during a brief job with the Texas Department of Human Services, I learned to say, *"¿Usted trabaja?"* and little else.

Fear aside, I was determined to do well and was captivated by the artistic and exotic Hebrew alphabet characters that flowed from right to left. I believed my years as an art and shorthand student would come in handy. Advice for success from The Reverend Dr. Jim Miles served me well, "Sit on a hard bench and don't get up until every Hebrew assignment is completed."

One afternoon in class, we were learning the *"U"* vowel or the *"Kubutz"* as it is called. I laughed and said, "I don't know if I can master the 'Kubutz' but I sure would be willing to 'Kibitz' a bridge game." Prior to seminary, my hobby was duplicate bridge and my goal was to become a life master like my mom. *"Kibitz"* had no more gotten out of my mouth when Rose Gander, a classmate, hollered out in astonishment, "Do you play bridge? Dr. George Heyer (Reformed Theology professor), Dean Shelton, and I are looking for a fourth. Would you be willing to play a foursome with us?" I replied, "Let me get out of Hebrew and I'll think about it."

When February rolled around, I was overjoyed by my *"A"* in Hebrew and bridge games were scheduled for Thursdays from noon to 2 p.m. Some aspects of the game were clear from the

beginning: Dr. Heyer kept the score pad on his right and an ash tray on his left; Rose kept the conversation going although talk was kept at a minimum since we played a serious game of bridge; Dr. Shelton always came late and darted out early; and I hosted and provided lunch since I lived on-campus.

Finances were squeaky tight for me and yet somehow I managed to scrape together enough to offer a light lunch of sandwiches, chips, Diet Cokes, and chocolate candies. Omi, Sarah and their friends liked it all, declaring Thursdays as, "The Best Day of the Week" for after-school snacks.

George was Bob's dearest friend, long-time drinking and gospel-singing buddy, as well as trusted colleague and confidante. I had heard *"George Heyer lore"* most of my adult life because after graduating from Yale Divinity School he served as associate pastor at First Presbyterian Church, San Angelo, Texas where four generations of my family had grown in the grace and knowledge of Jesus Christ.

Just prior to my move to Austin to begin seminary, George preached in San Angelo. He shared that for a time he and his wife, Hallie, had

two homes in Austin. One evening as they were leaving a party in separate cars,

George said, "I will meet you at home."

"Which one?" Hallie asked.

"Darling, home is where the art is," he said.

Hallie died from cancer shortly after the beginning of the '90 fall semester. Watching George grieve, as we played bridge, was instructive for me. I saw a man who very much wanted to be in control of situations and yet the cancer demanded he surrender control. Also, I observed a man of deep and abiding faith who in great sorrow was at ease living in the mystery of life and death.

The Thursday bridge games were an unexpected gift from God's storehouse of goodness. Class work was challenging. Bridge, on the other hand (pun intended), was familiar. Each member of our foursome had a large dose of competitiveness in our DNA; therefore, the only challenge it presented was getting in the correct contract and deciding how deep to go with a finesse.

I quickly became infatuated with the dean. He happened to bring a loaf of banana nut bread to the Thursday game that fell on my birthday. This

contribution was his alpha and omega contribution to the table fare and I *so* wanted to read something into his gesture, especially when he sang happy birthday to me. At the same time, I knew the idea was perfectly ridiculous—he just liked banana bread, bridge, and singing.

# CHAPTER 9
# Called To Service

******

*No, I've never lost faith; I do continue to be blown back by the love and patience God has for us.*

**moi**

******

What was also ridiculous is that my pastor and former boss, The Reverend Dale DePue, called to report that he was leaving San Angelo and that the session and Tres Rios Presbytery wanted me to serve as interim pastor over the summer. Every "no" I said was followed by a "yes" from DePue.

"No, I can't. This type of ministry is only done after completing two years of seminary. Besides, I'm already registered for summer Greek."

"Yes! I've checked and in rare circumstances the required Supervised Practice of Ministry (SPM) can be done earlier. With approval, of course." he said.

"No! There wouldn't be anyone on-site to supervise me."

"Yes! The Reverend Dr. Flynn Long from Big Spring has already agreed to supervise you. He'll drive over every week or so."

"NO! I'm not capable of preaching every Sunday."

"YES, that's been covered. Dr. Andy Edington, (the much loved friend of the Church and former president of Schreiner College) has agreed to preach most of the summer. Get the approval."

I made my way to President Stotts's office to seek his wisdom, hoping he would put an end to this nonsense. Instead he said, "What a great idea. I wish I had thought of it. Seize the opportunity."

Next, I went to visit Dr. Pete Hendrick, faculty advisor to SPM students. I was *certain* he would consider it an outlandish proposal. His only concern was that I had missed the SPM Orientation. Yet, like Stotts, he thought that it was a wonderful plan. He urged me to act quickly in

filling out the required paper work. "Ultimately," he said, "this will require the dean's approval."

I went to the dean's office with mixed feelings. I worried what he would say. In my dreams I wished he would say, "I don't want you to leave for the entire summer!" I was excited, however, to see him on a day other than Thursday.

I carefully gave him a chronology of the situation at hand. I could tell that he was not happy that he had been left out of the loop and he voiced his indignation. I apologized profusely for not following protocol. In the end, he said, "I do not *personally* approve of you not following the preferred academic plan; however, as dean I grudgingly approve."

I left Shelton's office wondering what he meant by *personally* and wished that he had elaborated. I also left understanding that the *dean* in no uncertain terms wanted to be third in line regarding the academic decisions for students at APTS.

The next morning I huffed up the 27 steps that separated the majority of student housing and seminary proper. These steps had become my way of memorizing the 27 books of the New Testament. They also illustrated the height and steep distance

in God's ways and my ways. I began to pray, "Matthew, Mark, Luke...Really God! Should I be grateful for your out-of-the-blue, major-ass change in my plans? Can't you tell that I am scared beyond belief?" By the time I got to "...1,2,3 John, Jude and Revelation," I was washed with peace and an inner voice saying, "Trust me and go see Bob Lively."

Bob Lively, an APTS alum and licensed professional counselor, listened to my fears about returning to my home church where I had previously served as a secretary *not* a pastor and where members were hotly divided about the pastor's leaving. "How will I survive?" I asked.

His suggestion for survival was for me to get a legal pad and write down my fears and thoughts about the divisions in membership. "Then on your first day at work," he continued, "lock the paper in the bottom draw of your desk. And remember, they've called you for your service, not your opinions."

I followed his instructions and at the bottom of my list of fears, I scribbled in bold lettering:

**"Get. Over. Bob. Shelton."**

Before heading out for the summer, I went to say good-bye to the dean under the guise that I needed instruction on how to cincture the alb that I had been advised to wear in worship services. (I really did need instruction!) He taught me how and then offered to walk to the car with me to see if the U-Haul trailer was properly connected to my '78 Olds 88.

He visited with Omi and Sarah and asked if they were excited to head back to San Angelo and see and play with their friends. He laughed that they were mostly excited that our apartment had a swimming pool. Then he slapped the car door, much like one would a horse's rump and said, "You better hit the road." I drove off watching him wave in the background through my rear view mirror and looking ahead into an unknown future of serving well-known and much-loved friends.

Before dutifully locking my legal pad in the bottom desk drawer on my first day of ministry, as Lively had suggested, I re-read,

**"Get. Over. Bob. Shelton."**

As soon as I pulled the key out, the administrative assistant came into my office and

asked, "Did you get to meet Bob Shelton this past year? I think the world of him. He led a workshop on *The Theology of Willie Nelson* at this past year's Association of Professional Administrators Conference and he was just terrific!"

Her question discom**Bob**ulated me and I stumbled over my words. "Yes. Yes, I got to know Bob Shelton. We pla-play-played bridge together each week. Umm, no, I have not gotten to hear him do his Willie stuff. I've heard it is good. I'm glad you liked him."

Midway through the summer, Rose Gander called to inquire how things were going and to see if I'd been able to play some bridge. Toward the end of our conversation she said, "Well, the dean wanted me to call and see how you were doing."

Conflicting emotions of anger and joy began warring inside of me. Anger won and I said, "Well, I'll tell you what — if the dean wants to know how I am doing, he can call me himself." That ended the conversation.

While getting over Bob Shelton was not going well, engaging in ministry was. Visiting folks in the hospital, listening to members share the faith, and role-playing Joseph for Vacation Bible School was humbling, inspiring, and

affirming. Hearing Andy Edington preach with humor and through storytelling; preparing liturgy and leading worship; and keeping up with committee work and plans were life-giving, exhilarating and exhausting. In tense moments, I would recall my mentor, Dr. Fane Downs's secret to meaningful ministry. With a deadpan expression, she said, "Come to terms with the fall of humankind and the forgiveness of sin."

At the end of the summer, Dr. Long, who did serve as my supervisor, invited me to Big Spring to have dinner with him and Grace, his wife, so that we could evaluate the summer. As soon as I sat down in their living room, Grace asked, "So do you love or hate Bob Shelton? Folks usually fall into one of the two camps."

I choked on my sip of wine and my hands turned cold. What could folks *not* like about Bob? I raced through an inventory of just some of the qualities I loved about him: sharp and quick wit, easy-going nature, intellect and wisdom…. I made a veiled attempt to make light of the deep contents of my heart and took awhile to respond, "Well," I drawled elongating the "Lllll's, I suppose I fall into the camp of people who love him."

She gave a wide grin, lifted her glass in a toast and said, "So do I!"

# CHAPTER 10
# Crazy

******

*It [life] is an endless procession of surprises. The expected rarely occurs and never in the expected manner.*

**Vernon A. Walters**

******

Word spread quickly across the seminary campus causing all kinds of excitement. Dean Shelton was going to teach the fall Worship class because Dr. J. Frederick Holper had been called as professor of liturgics and homiletics at Union Seminary in Virginia. I was already registered for Worship and Reformed Theology taught by Dr. Heyer. I wondered what it would be like to have

bridge buddies as professors and to call them by their first names as was APTS custom.

On the first day of worship class, Bob hurriedly shuffled into the classroom carrying a half-empty cup of coffee and his dog-eared manila folder of class notes. Over the semester, we learned that he was *always* in a hurry—taking time for just *one* more phone call, listening to a fretful-soon-to-be graduate, or wise-cracking and laughing with a group of students. We learned, much to John Calvin's chagrin, Bob took *pride* and subtly nurtured his *"half-empty"* philosophy. His rationale was that *"pessimists are never disappointed."* Furthermore, we learned that a sip of coffee had never passed his lips until he was promoted to the dean's office. Reared in the Cumberland Presbyterian tradition, his family viewed coffee in the same light that Hassidic Jews view bacon. Yet on his first day as dean, Fern Chester, his administrative assistant, brought him a cup of Joe, and not wanting to hurt her feelings, he took a swig, and thus began a morning ritual.

Bob was called in 1970 to APTS to teach worship, homiletics, and various other required classes. He had immeasurable gifts for teaching. He never referred to his notes that he religiously

carried. Instead, he imparted the history, practice, and personal insights into the subjects he taught through stories and one-liners that left indelible impressions on his students. Over the years, lines from his lectures became known as "*Sheltonisms.*" For example:

> *God calls a person into the ministry when God can't save that person any other way; it is a last ditch effort on God's part.*
>
> *People in our churches are not people who have never heard the Gospel. They are people who have heard it and misunderstood it.*
>
> *Full understanding is always beyond us human beings in every instance.*
>
> *If you can understand it [for example: The Incarnation, The Atonement, sacramental mysteries,] don't believe it.*
>
> *The best leader of worship is someone who never calls attention to herself or himself.*

The above *"Sheltonism"* underscored his insistence on preparation for leading worship. He recalled an occasion when a student's failure to practice reading the scripture passage resulted in: *"Let all the earth fear the LORD; let all the inhabitants of the world stand in 'a we' of God."* (As in two syllables—short *a*, long *e*).

Bob wasn't afraid to laugh at himself to make a point either. He began instruction on the rubrics of baptism with a story about how nervous he was before his first administration of this sacrament. To prepare, he got his wife, Barbara, to crawl into their unfilled bathtub so that he could practice pouring the water. When he freaked out that he was going to bang her head against the enameled cast iron, she calmly said, "Bob, remember there will be water."

His class met in the chapel to begin learning about The Eucharist. His mood became pensive as he shared that countless mornings after Barbara died in February 1980, he would sit alone in the chapel praying questions to God, "If Barbara is dead, why am I alive?" and "How can life ever make sense without her?"

The lesson continued with a story about his ongoing argument with a *"phantom of the chapel."* In

the early mornings he came to pray, he would find the communion table placed at the far side of the chapel. Dutifully, in the Shelton-stubborn way, he'd pull it back to stand in the middle of the center of the aisle, at the foot of the chancel steps. This went on for months until the battle was won, the strife was o'er, and The Lord's Table was left where Bob had moved it. He believed The Lord's Table is a sign and symbol of God's gift to the world and a reminder of our personal and corporate call to be instruments of God's reconciliation; therefore, the communion table *ought* to always be in the center of the worship space—not cast to the side.

He often said, *"Nowhere in the church is true democracy expressed but at The Communion Table and a Willie Nelson concert!"* The strength of the Willie concerts, Bob believed, lay in their diversity. There were representatives of all social, economic, educational, and ethnic backgrounds. There were all types of fashion attire, and all ages paid the same price for any seat in the house. He regaled the class with stories from past concerts. He dusted and polished them with theological insights so that the stories became shining illustrations of acts of worship and God's love and mercy. One of the best

stories was about Peg Leg Johnson, an octogenarian whose face was a radiant reflection of God's countenance as he waltzed to Willie's music with an ingénue picked from the crowd. The couple commanded the dance floor with their fluid motion keeping time with steps and circles revealing beauty incarnate, unique grace, and an unspoken hope for all.

Bob was both passionate and opinionated about worship. First and foremost, he understood worship as an act of obedience to the sovereign Triune God. He modeled ways for students to pray by starting with a proclamation, "Let us pray." Then he'd allow moments of silence in order for the worshiping communities to center their hearts in reverence. For emphasis, he would add, "Worship is about obedience, **not** about etiquette." Years later he'd still wince when worship leaders would begin times of prayer with "Will you pray with me?" or "**Please** pray with me."

Likewise, if worship bulletins listed The Prayer *of* Illumination it would put him in a state of prepositional apoplexy because it is The Prayer *for* Illumination. *For* emphasis and lasting impression, he would throw a Bible on the floor to remind us that the Hebrew word for book is Bible;

*therefore,* without praying *for* illumination from the Holy Spirit, we were simply reading myths, engaging stories, and poetry from any other books on the shelves. Prayers *for* illumination before reading Scripture were essential to hear and see the presence of our living God.

He also stressed his strong preference that Scripture readings be listed as *First Scripture Reading, Second Scripture Reading,* and so forth rather than *Old Testament Reading* and *New Testament Reading.* He maintained that *all* Scripture is the *one* authoritative revelation of the living God; hence, one section doesn't override the other. Over the years, his leadership and influence formed and informed a wide swath of students, ministers, and laity.

After we were married, I recall sitting at our dinner table indignant about what I considered poor worship leadership at a denominational meeting. "Bob," I said, "you told me that **you taught** this person!" Slowly wiping his mouth, he replied, "Fran, I said that the person was **in** my class. There can be a big difference. And it isn't helpful to make an idol of worship." Lesson ended. Lesson remembered.

While in seminary, it was difficult for me to reconcile my ongoing, *CRAZY* feelings for Bob. After all, I had vowed to God, that *if* God (I am not beyond pleading or bribery when it comes to prayers) would help me get out of my first marriage I would *never* marry again. I'd also be willing to go and serve the people of God anywhere (pretty please, no cold weather) and in any form of ministry. At one point, I reached a level of peace in discerning that God was simply showing me that my heart still had the capacity to love in romantic ways. That was encouraging to know about myself.

Our regular Thursday bridge games continued throughout my final year at seminary. This is when seniors feel really *Crazy!* After all, we had entered seminary with the hope of getting out, being ordained as Ministers of Word and Sacrament and at last beginning full-time ministry. We didn't realize that we would be gifted with meaningful relationships forged around Diet-Coke-fueled conversations about everything from the vagaries of Hebrew vocabulary to the intricacies of a Texas political system that had somehow elected a delightful apostate like Ann Richards.

# CHAPTER 11
# Seminary Worries

******

*Why do I let myself worry?*

**Willie Nelson**

******

Persons are often surprised that seminary students worry, especially since they are or ought to be people of faith. And yet there is plenty of cause for worry among students. For starters there are the four ordination examinations that must be passed in order to seek a call in the Presbyterian system. They included: Bible (exegetical work on a Hebrew or Greek passage of Scripture), Reformed Theology (any question from Atonement to the Zurich Agreement; Worship (probably *the* easiest

of all, especially since we had Bob as our professor); and **Polity** (seeking knowledge of dynamics and divisions of power and authority in ordained groups). Exams are administered in September and February with February being a time to retake any failed exams and pray for passing grades.

There was also the pressure and excitement of senior preaching. This involved designing a service of worship, preparing a sermon, and preaching in front of the entire seminary community: professors, administrative staff and students, not to mention any stray friends or relations who might wander in.

Or perhaps a better question, "where in the world will I be called?" Professors were very helpful in this process serving as references and contacting colleagues to see if there were any upcoming openings. At one point in my call search, Bob suggested that I apply for an associate pastor call in Pennsylvania where a friend of his served as head of staff. That was when I realized that the bridge games did not mean nearly as much to him as they did to me. I half-heartedly laughed off his suggestion by saying that it would be a long commute for our faithful foursome. Now

I whole-heartedly knew that I was truly *crazy for being crazy* about him, because it was common knowledge that he dated a number of women. He also made it known that Tammy had made it very clear, "If you ever get married again, the woman **has to be** older than I am." He expressed naive indignation at such a request.

If I had wanted a clue as to how Bob felt about second marriages, I didn't have to wait long. The next lesson in worship was on marriage. He launched into a shtick, that frankly many considered heretical, "Second marriages are the only ones that count." His pronouncement put a shocked face on many of us, which he delightfully mimicked. The gist of his explanation was that first marriages never count because of any number of reasons: couples are too young, lack self-understanding, are clueless of personal values, and they're overly confident that detestable quirks in partner or partner's family will vaporize. After securing a home with a large mortgage, a white-picket fence, 2.5 children, a dog, or a gerbil named Calvin, (no particular order required in obtaining the aforementioned), a couple would look at each other one morning over toast and marmalade, and say silently or aloud, "Now who are you? Clearly,

you're not the person I married." At that point Bob emphasized, "a first marriage could be forged into a second marriage—one more authentic, intimate, and joyful than the original." He also acknowledged that through his years in ministry and at the seminary, he had seen that often divorce was the healthiest decision some couples could make.

While the class was still trying to process his viewpoint, he confessed that he had been put on the red carpet by a Texas presbytery (a higher Presbyterian governing body) to defend his remarks. He stood his ground and underscored his belief that all first marriages can *become* second marriages—and *that* is what counts. He added that he also had the secret to a divorce-free society, "All it takes is for a couple to decide early on who will make all the decisions and the other person agrees to comply without stipulation." With that the class ended with a loud and long groan. I walked home muttering, "That man is the CRAZY one."

The louder groan, however, came from me several weeks later when I learned that I had failed, FAILED the worship, the WORSHIP ordination exam. Clearly, my idea that the worship exam would be the easiest by far was far, far from

the truth. Dr. Eleanor Cherryholmes, director of admissions, overseer of ordination exams and also a regular substitute for the Thursday bridge games, knew that I would be devastated by this news. Therefore, in a pastoral attempt to ease the pain of failure, the embarrassment of failure, and the delay in receiving a call to fulltime ministry because of FAILURE, she came to my apartment to tell me the news face to face.

I would not have wanted her job. She sat ever so patiently as I crumpled on the tile floor of our apartment. Frankly, I didn't want my job either, which involved pulling myself together, managing my scared-shitless anxiety and pretending to be happy for classmates who had passed all four exams. Perhaps the Apostle Paul's greatest challenge to the Romans (12:15) and to us is *"to rejoice with those who rejoice...."* The second half, *"to weep with those who weep"* is much easier. At best, all the rejoicing I could do for others was a thumbs up accompanied with a subliminal message, "Please do not talk to me because I may burst into tears or throw up."

George even came over to my apartment to commiserate with me (as faculty he had gotten ordination results). He said, "Failing an ordination

exam is like a badge of courage." I didn't understand what he meant by that and was too embarrassed to ask. Quite frankly, I still don't know what he meant. He even tried to get me to see the humor in the situation that I had failed the subject taught by our bridge buddy. He perceived that I wasn't going for the humor and had the good grace (he always had buckets of good grace) to leave.

When I wasn't able to get in touch with my Mom to break the news that my heart was in a world of worship hurt, I called Margie, my aunt. She, without hesitation said, "Call Bob." The two of them had hit it off after my senior preaching worship service. I told her, "He's not here. He's off some place, God knows where, for a preaching gig."

"That is no excuse!" she said. "Find out where he is and call him." My fear was divided by two. There was the fear of not doing what my aunt believed to be the most helpful thing for me and the fear in reaching out to call Bob. At times I have come to believe that fear divided equals courage not yet activated. Other times the division may produce a pathetic, versus holy, surrender. Both

cases produce movement that beats the heck out of emotional paralysis.

I tracked down the telephone number where Bob could be reached, took a deep breath, and dialed. His host answered the phone and said that he'd get Bob. The wait was so long I thought maybe Christ was coming again. At last, he answered. By *"he"* I mean Bob, not He, as in Christ. Immediately, I began sobbing and doing my damndest to articulate that I had failed the worship exam. Articulating great loss is redemptive—finding the words, speaking one's pain into the vast womb of the cosmos, hearing the words and sometimes seeing the very words stand for a brief period of time waving adieu through sound and space is mysteriously healing.

Bob listened and demonstrated, even over the phone, a ministry of presence and an understanding of the balm of silence. His standard-stock advice delivered in such a way that it felt first time and personal was, "Let's take the long view." Calmly, he went on to say that I would get the exam back and be able to see what remarks and suggestions were made by the graders. Also, this would very likely help me be more empathetic to future parishioners who experienced personal

failure because not everyone experiences failure in the form of a professional exam. For some reason, in seeing *"the long view,"* I was able to redirect my focus on the fact that I had to pass the exam when it was offered again. When I look back on this conversation, I am aware of two things. First, he must have had similar conversations with seventy times seven former students who later passed exams on the second try. Secondly, calm is such a rare and grace-filled gift.

# CHAPTER 12
# Turning Point

******

*You cannot change your destination overnight, but you can change your direction overnight.*

**Jim Rohn**

******

I couldn't spend much time thinking about retaking the worship exam in February because I had to think about passing my four semester exams and planning a birthday party for Sarah who was turning eight. While juggling these responsibilities, Jay Brown, a friend to whom I had hinted of my *CRAZY* hankerings for Bob, asked me if I wanted to go with him to a Christmas party. I declined and began reciting my litany of academic

need-tos and parental want-tos. He gave an understanding nod, a shrug, slowly walked away, and said over his shoulder, "Well, I have it on good authority that the dean will be there. I just thought you might want to go."

"Wait just a minute," I chimed. There was really no need to wait because my decision to go to the party was made in less than a minute. The immediate power and speed of rationalization in decision making is fascinating, if not downright *stupid!* As a matter of fact, Willie Nelson originally wrote his famous song as *"Stupid"* rather than *"Crazy."* Later he was convinced that *"Crazy"* was more poetic and lyrical.

Trying hard to be sensible, I said that I could only stay at the party for one hour and Jay promised that we'd leave after precisely one hour. I could forget my worries for an hour; however, I could not forget that I had a 25-page paper due and an upcoming exam in two days. When Jay and I got to the party the dean was not there. Rumor had it that he was making the rounds about town to several parties and this party was at the end of his list.

When the hour of departure arrived, lo and behold, Bob walked in. John Evans, the party host,

quickly handed him a scotch neat and refreshed everyone's holiday cheer. Someway, somehow that holiday cheer managed to fill the living space to capacity, requiring Bob and me to move outside onto the small, second-story porch. In that space, time seemed to be suspended and we bantered with ease, declared a tie for the quickest of wit, and protested too much that neither one of us knew that the other would be at this party. And I got to do some holy gazing into his coy, cerulean eyes before heading home.

    On the way back to the seminary, Jay and I stopped at the home of his fiancée, Tammy Gregory. She had just pulled from the oven a loaf of cranberry nut bread. We devoured several slices before I headed home. I was too tipsy to study and it was too easy to crawl into bed. No sooner said than done, the phone rang. I made a mad dash to answer so that it wouldn't wake up my kiddos. Plus late night calls scare the bejeebers out of me because as a rule of thumb they carry messages of not-so-good-news. *This* call was an exception. It was Bob! He said, "I just got off the phone with Tammy. I thought you might be over there, but she said you had gone home. She's invited me over for

the little bit of cranberry bread you left. You want to meet me there?" **Well, of course!**

There are many ways to describe that evening. It didn't take me long into our conversation to ask, "So — how old is Tammy?"(daughter Tammy; not bread baker Tammy.) "She's younger than you are. I've already checked that out." he said. My heart beat a happy dance while the four of us bantered back and forth until the cranberry bread had turned to crumbs. Over the years, we understood it to be an evening that turned each of us and our lives around. There continued to be a long-standing debate, with no resolution, about which one of us turned first. At the time and to this day, John Evans takes full credit for arranging the turn in our lives and our decision to see each other after I graduated and it would not have to be only for bridge! Each Sunday when I see John in church, (we've both relocated to Dallas) I give him a hug and a kiss of thanks.

The CRAZY parts of our relationship continued. I received a call as associate pastor for youth at First Presbyterian Church, Bryan, Texas. In the process of finalizing the call, I did not pass the oral examination. Failure, again! Man, oh man,

was I ever growing in empathy for future parishioners! The six men from New Covenant Presbytery who administered the exam also extended me grace upon grace by giving me one month to prepare for yet another oral exam. Thank the good Lord, the chair of the committee was, Dr. Murray Milford, a professor at Texas A&M University. He assured me that he had seen top PhD students get the jitters and be required to retake their orals and that the church committee was behind me one hundred percent. His wisdom and words gave me comfort and hope.

Such comfort and hope, plus hours and hours of study were essential to my passing the oral examination, beginning ministry and planning my ordination service. And at last, Bob and I were planning to go public with our *CRAZY* love affair. The time and energy that we spent in discerning the best time to share this news was in direct proportion to lovers thinking that the entire world would care. In our tunnel vision of love, we thought our announcement would be front page news.

Delay after delay occurred so that we felt it was not appropriate to share with Bob's children, our co-workers and congregations, and let's not

forget every walking and breathing stranger who was willing to listen. During this time Omi and Sarah developed a code. If Bob Leslie, my boss and head of staff at First Presbyterian called, they would say "Bob wants to talk to you." When Bob Shelton called, they would say, "It's B.O.B."

One night B.O.B. called and was so distraught that he was unable to collect his thoughts much less put them into words. In a bare a whisper he said that Tammy had received a diagnosis of breast cancer. Struggling to digest the ramifications of breast cancer, the disease that caused Barbara's death and now threatened Tammy was terrifying. Silence was all we could speak. The next morning Bob was still so consumed with fear that he accidentally rammed the car in front of him. Thankfully, only bumpers were hurt.

The following months were both scary and encouraging. Waiting for the surgery was scary. At the same time everyone was encouraged that the radiologist had found the cancer when it may have been invisible to a less practiced professional and Tammy's doctor was noted as being the best in the field. The good news is that Tammy recently ran in the Susan G. Koman race and with each stride in

pink we all gave thanks for the 25 cancer-free years!

During those weeks, Bob and I learned and practiced the wisdom of Lao Tzu:

> **Being deeply loved by someone
> gives you strength,
> while loving someone deeply
> gives you courage.**

Strength, courage and healing became our prayer mantra. Although I had not met Tammy face to face, I became acquainted from a distance through Bob's regular reports about facets of her physical, emotional and spiritual strength and courage. It is near impossible to calculate the exhaustion people experience in times of intense stress and grief. The sheer weight of one's imagination of possible, not likely, scenarios is a heavy burden.

Several months later, in April of 1994 (take note, this date is important!) Bob and I were able to once again look to the future. As much as my heart did not want to admit it, my brain kept teasing me with the possibility that marriage for Bob was never going to be in the picture. Bob assured me

that it was and he framed the conversation like so, "Yes, I want to marry you! I've been seriously thinking about this. I believe we should get married in 1998 because I will be retired and you will have served in Bryan long enough for a first call." Suffice it to say that Bob was always a practical planner and I'm a straight-forward dreamer so I responded, "Like hell! If that is your proposal then I say yes. **But** we're going to get married this year. You can pick the date."

Laughter and more laughter broke out after this exchange. I reminded him that he truly was much more of a romantic than making a business-like marriage proposal for four years out! And he reminded me that I was usually much kinder and liked all of his ideas. The date was set that afternoon for November 26, 1994. Small details, like meeting his children, would be worked out later.

# Help Us Accept Each Other

WORDS: Fred Kaan – Hope Publishing
3rd and 4th Verses

Teach us, O Lord, your lessons,
as in our daily life
we struggle to be human
and search for hope and faith.
Teach us to care for people,
for all - not just for some,
to love them as we find them
or as they may become.

Let your acceptance change us
so that we may be moved
in living situations
to do the truth in love;
to practice your acceptance
until we know by heart
the table of forgiveness
and laughter's healing art.

# Chapter 13
# Help Us Accept Each Other

\*\*\*\*\*\*

*Have a big enough heart to love unconditionally, and a broad enough mind to embrace the differences that make each of us unique.*

**D.B. Harrop**

\*\*\*\*\*\*

Respecting Bob's wish to not tell his children and their spouses about his Alzheimer's diagnosis was eating my lunch. I was hungry for empathy and support, which was stoking my feelings of anger. To make it worse, my anger was misdirected toward his children rather than toward Bob who had made what I believed to be an utterly ridiculous request.

Truth be known, the ground or dirt of the majority of our arguments were around our well-entrenched individual family systems. This reality was in tension with my professional knowledge and insights that I shared while facilitating bereavement workshops and retreats. In these settings, I stressed the utmost importance of acknowledging and respectfully accepting the different ways family members of the deceased respond to the reality of death and to the unfolding future without the physical presence of their loved one.

Acknowledging differences in personalities and coping skills generally comes easy when one is *thinking* about the differences. In the best of times, these differences are acknowledged with light-heartedness and possibly humor. In our family alone we have planners and spontaneous types; minimalists and maximalists; strong silent types and talkers; readers and TV watchers; sweet lovers and salt lovers; chefs and take-outers; church goers and church avoiders; and let's not forget Democrats and Republicans or the god-awful third parties that skew (or screw) the elections. The list can go on and on because families are diverse and

people change, sometimes dramatically, or more often, ever so slightly.

It is the *"respectfully accepting"* that is the challenge since most of us think we are pretty damn good at handling life so others ought to follow our footsteps. My guess is those of us who feel that way are labeled *"opinionated"* which is fine when others agree with us. It is when we are labeled *"wrong"* and there is disagreement that it's hurtful. I frequently recall this nugget of wisdom I heard at a conference on reconciliation:

**It's not right. It's not wrong.
It's just *different*.**

On certain occasions in our marriage, this was a helpful mantra for me. Whereas, some couples are attracted to one another by their differences, Bob and I were attracted to each other through our shared values of faith, family, and fun. What we came to *"respectfully accept"* was that we demonstrated the value we placed on families in very different ways. Through easy going conversations and sometimes tense moments we shared these differences and for the most part

came to better understand and *respect* one another's differences.

Oversimplifying what I believe to be significant factors, I will share a bit of my background first. My family was small. I have one sister, Alice, who is smart, funny, a rock, and a personification of energy. Although our parents held respected different views on sacramental theology and ecclesiastical polity (Roman Catholic dad and Presbyterian mom), they agreed on the importance of practicing our faith, all of us working to make ends meet, placing a priority on education, and coping through laughter. A bumper sticker on my Prius reads "Laugh Until Life Makes Sense."

Across generations, aging parents moved to live and be cared for by adult children and grandchildren. In exchange for the care, grandmothers and grandfathers shared stories of perseverance in difficult times, gave daily lessons that cultivated patience, passed along recipes for comfort foods enjoyed to this day, and dispensed coins of *"familyisms"*. My maternal grandfather, in his Swiss brogue would describe and dismiss difficult people as being, "Just cruzzy." My

maternal grandmother would say, "Grief does not make you; grief uncovers you."

Above all and over the long haul, they gave us the un-replicable gift of discovering abiding joy that is nurtured by three generations of faith, quirkiness, and humor living under the same roof and eating at the same table. Meals were prepared by divvying up the tasks. One would go to the grocery store to buy what sounded good that day, depending on the weather or amount of money in the pocket. One would cook the main course; another would prepare the side dishes; and another would set the table. We all knew that supper was served at straight up six o'clock and I believed it was the best time of the day.

In part, since my dad was an alcoholic, and all the Al-Anon and Al-teen meetings in the world couldn't prevent it, we were enmeshed. Personal boundaries were permeable and unclear, which is a nice way of saying non-existent. We, my mom, sister, and I, knew nothing different than to be in this life together, to feel each other's emotions, and to help each other out come hell or drought of sober days. I learned that alcoholism is a family illness. I understood it to be the only illness a *family* suffered; therefore, when an elementary

school friend's parents divorced, I commented, "I didn't know **your** daddy drank, too." With a startled look, my friend responded, "He doesn't drink. He just has a new girl friend."

On the other hand, Bob's family was quite different. For starters, it was large. There were a total of nine Shelton children born over a span of 20 years. Before Bob and I married, I felt a bounded duty to recite their names in chronological order: Frances Juanita (called Juanita because they did not like the name Frances), Myra June, Mary Ruth, James Roy, Helen Louise, Charles Warren, Wayne Allen, Kathryn Sue, and Robert McElroy. His dad was a Cumberland Presbyterian minister, a teacher, a school administrator, and a farmer. His mother was a Methodist, a pianist, a lover of poetry, and a regular bearer of intelligent, independent, and industrious children.

They held matters close to their hearts, achieved excellence in educational paths and vocations, and were quite independent, except when singing. An often told story is that Mary Ruth was home from college in the summer of 1934. It was an uneventful summer, with all things on the home front being the same old same old. In mid-October, her father wrote to her saying that

the family had recently been surprised by a little night visitor. His name was Robert McElroy. It was not until she came home for Thanksgiving that she realized that the little night visitor was her baby brother! There had been no conversations about the upcoming birth that summer. Bob would explain, "My mother simply did not talk about those things. She wore loose clothing most of the time and siblings did not notice that another child was on the way."

Each child was especially gifted with intelligence (skipping grades in elementary school which they casually shrugged off saying, "that was just common back then"). The majority easily received post graduate degrees, with honors and went their own ways. Each excelled in vocations of choice (military, education, music, theology or computer science in the time when the general population was clueless about computers).

On a fall Saturday afternoon when Bob was getting ready to suit up to play football for Maryville College his mother was killed in an automobile accident. One of the curves along the mountain roads of Tennessee was too much for his father to maneuver and the two tumbled down a steep ravine. They were on their way to watch

Robert, as they called him, play ball. Bob recalled that he kept looking up in the stands for his parents during the game and that at halftime folks seemed to look at him funny. Later, he learned that the decision was made to tell him the tragic news after the game so that his talent and attention would be on the field.

The stunned children, some with spouses and children, gathered for her funeral in Louden, Tennessee where their parents were living. Their father had to remain in the hospital. He was later able to travel and attend her burial in Illinois where the family had lived and farmed. Bob often spoke about his mother, describing her as "gentle, quiet and full of faith." He remembered her saying, "Even if there is not a heaven, I would choose to live my life following Jesus." His fondest memories were of times when she read poetry to him.

These memories were also highly cherished by Bob's, sister, Kathy who traditionally visited us each Thanksgiving. Later, after her husband (also Bob) died, she visited during the summers. She was affectionately known as my Bob's *"favorite sister."* Kathy generally took the lead in planning summertime Shelton Reunions. I was totally

fascinated by these reunions and the number of people, the visible reminders of the power of genetics in appearances, mannerisms and personalities. The stories of family lore were entertaining and fascinating to me.

The Shelton sisters were not allowed in their mother's kitchen. This was both a puzzle and a relief to them. Very probably, this was an assured and cherished three-times-a-day space, where their mother could be by herself. The girls were relieved because they possessed no willing desire to cook. They would rather be studying, singing, or reading. As adults, they owned up to the comments that they were terrible cooks and the majority was grateful that they had married men who were willing and able to get meals on the tables.

At the Shelton reunions there was plenty of hymn singing. Wayne would play the piano for the sisters to perform. And perform they did with each strong soprano determined to have her voice heard over all the others. The group circled in worship at the close of each reunion. Bob was unofficially anointed as the *"family pastor."* He humbly accepted this role and regarded it as a

pearl of great price, especially since there was more than a hand-full of ministers in the extended family. With this role Bob officiated at joyous occasions of baptisms and weddings, as well as comforted family members and friends at funerals by giving witness to the resurrection. As the baby of nine, there had already been many occasions of joy and sorrow, with more to come.

I continued to waffle about whether or not to talk to Tammy and Jim. I agonized over the pros and cons. I desperately wanted to honor Bob's request, as I had done many times before. Although I had never seen or experienced Tammy or Jim being angry, I was nervous about their response to the news. After all, the reality was that I was their step-mother. From day one, however, we had connected and related to one another as incredibly special friends with a very large common denominator — our love for Bob. Perhaps, I was projecting how I would respond in such a situation: "What the hell?! You haven't told us what was going on with our dad?" (I *must* be projecting because I have never ever heard either of them use such slang or profanity.)

Bob was still adamant about not telling them. I decided to present my dilemma, in front of Bob, to his neurological psychiatrist. Her first response was, "Have they not noticed? Have they not inquired about his behavior?"

"I do not know if they have noticed all the differences. They have not mentioned it or asked questions," I responded.

"Yes, they should be told. For starters, what if you fall down a flight of stairs or wind up in a wreck and are hospitalized? That would not be an ideal time for them to first hear the news. They would need to know how to care for him, in the event you could not," she continued.

I was grateful for her agreeing that they needed to be told. I was not so grateful for her reasoning. The thought of falling down stairs or being hospitalized did nothing to lower the anxiety I felt in sharing this information. I also did not know the best time to tell them. Our times to get together were in October for Bob's birthday, Thanksgiving, Christmas and the $4^{th}$ of July. Sharing this news at one of those times would certainly place a pall over the celebration.

Also, how would I share the news? "Oh, by the way…". "I want you to know…".

"Your dad does not want me to tell you this; however, ...." Or begin by saying, "For the last several years, you dad has been afflicted with Alzheimer's." Should I take his neurological report along with me? Would I begin by saying, "Your dad is more amazing and braver than we have ever thought in the ways that he has received the earth-shattering news that he has Alzheimer's." I just did not know when or how to talk with them and yet I desperately wanted this weight of silence lifted from my heart. I decided that like many other times in our lives, the opportunity would present itself.

In October of 2014, just days after her 82$^{nd}$ birthday, Bob's favorite sister Kathy was facing imminent death from pancreatic cancer and what I discerned measures of dementia. Tammy decided to travel to New York so that she could be with her aunt. The bonds between Kathy and Tammy and Jim were steadfast, strong and tender. Kathy had lovingly and lightly stood close to them in the thick and thin of life out of her devotion to and in memory of their mother, Barbara who had died thirty-four years earlier. Kathy's death would mark yet another signal moment in the life of this family.

Tammy wanted her dad to go with her and travel plans were quickly made. I did not have much time to worry about how Bob would manage the trip, although worry is not a respecter of time. How was I going to prepare Tammy to oversee the care of her dad when she had no clear vision of the circumstances? I asked her to tell Kathy's children that Bob would *not* be able to officiate at her funeral or graveside; however, he could read scripture and/or speak about her life, if they wanted.

It was clear that Kathy wanted to hear Bob's and Tammy's words of love and gratitude for the joy that she brought to them and so many others through her faith, teaching, singing, and laughter. She died shortly after they arrived at her side. It was a sad time for all of us and many, many of her former students. Her life, as "a lamb of God's fold, a sheep of God's flock, and a sinner of God's own redeeming" was a living testimony to the hymn, *"How Can I Keep From Singing."*

As soon as Bob returned home, he began working to put thoughts about his sister into words. At this progression of the disease, he was not able to write legibly or retrieve the depth of thoughts that had previously flowed with ease.

Now this process was laborious for him, which infuriated him and seemed to make him even more confused. I look back on this time with deep remorse. If given the same circumstances, I would have told his children much earlier, gotten him off the hook of previous family expectations, and eased his heart and mind with more hugs.

Instead, we discovered that a new way of preparation for him to speak was dictating his thoughts to me. It was both grueling and a labor of love for him. After working on this approach for several days, I printed off his thoughts in 16 point type. He practiced his delivery across the 400+ miles of travel to McKenzie, Tennessee where Kathy and Bob had lived and served for many years.

Pinpointing the visceral change in the heart that took place on this trip is difficult. Perhaps I do not want to see my selfishness, my neediness, and my displaced anger. I felt an intense protection of Bob and I felt utterly alone in the midst of this large family. Dinner plans were made at a diner off the GPS grid. The wandering through unknown territory in the darkness of a fall night served as a metaphor of our personal journey. The next morning, the hunt for a small town, well-kept

secret breakfast spot did not include us. The slight was a reminder to me that Bob and I were the older branches in the family tree. The younger limbs yearned to swap fond and fun memories about Kathy among themselves.

Bob and I holed up in our room as he went over and over his talk. Jim came to our room and shared the numerous and enriching times that he and Kathy had enjoyed in New Orleans, at concerts of different musical genres and in moments of their quiet reflections about life.

I believe I was so entrenched in my own grief over Bob that I was unable to erect emotional boundaries (remember my history with boundaries?) for each family member to personally grieve Kathy's death. Instead, my emotions and ever-looming, faceted present and future reality became like an oversized and ugly hairball that I coughed up and said to Jim, "I need to talk to you and Tammy in the near future about some stuff."

"Sure," he said giving me a hug. Then he went to get ready for the funeral.

## Chapter 14
## Getting To The Truth

******

*The truth is, we all face hardships of some kind, and you never know the struggles a person is going through. Behind every smile, there's a story of a personal struggle.*

**Adrienne C. Moore**

******

The time had come for me to go against Bob's wishes, tell his children, and release the secret into God's grace, light, and truth. Jim made plans to drive to Dallas on a December weekend that Tammy and Rich were home and we set a Saturday morning time. I was so incredibly nervous. I showed up and rang the doorbell. No

one answered. Peering through the glass I could see that there were no lights on in the rooms. I walked around to the back and saw that there was only one car under the carport. My heart raced and I thought, "What the hell?"

I buzzed Jim and said, "I thought we were going to meet this morning and talk."

"Fran," Jim said, "I am coming up next weekend. It is next weekend that we are getting together. Tam and Rich are out of town this weekend. We will plan to come over to your house so that we can talk."

"Well actually, I want to talk to you all without your dad present. I am sorry I got the days mixed up," I said with my heart thumping EmBarRassIng! It was in that moment that I realized the treasure trove of things I had tried to reduce my anxiety were all unsuccessful. Being a spiritual director by profession, I had relied on meditation and contemplative prayer that were helpful in times of ease. Breath prayers where I crafted my own prayers to fit the occasions of stress such as inhaling *"Wise and Gracious God;"* exhaling *"Restore my sense of sanity"* or inhaling *"God of boundless compassion;"* exhaling *"Grant me peace and patience"* helped in times of short-term

stress. I had even followed the regimen suggested by a woman specializing in homeopathy—giving up coffee for a period of time. No relief!

A litany of regular massages had no long-lasting results. Finally, after my general practitioner checked and rechecked my thyroid she said in her salt of the earth tone, "Girl, you have been caring for your husband all by yourself ever since I met you. Your history shows that your grandmother and mother wrestled with anxiety. Why are you so damned afraid of taking a prescription that will help you so much?"

"Because I want to be tough. I want to be able to handle things. I worked with a group of people where most of them were all taking meds for depression or anxiety and I just didn't want to join the group," I said with all honest resignation.

"You are tough. You are handling things. I simply believe medication would make the long road a little easier. Are you willing?" she said.

"Sure," I said, sloshing through the last bucket of tears I would shed for a long time.

Before my new prescription could take effect, it was the *correct* Saturday to visit with Bob's children. They greeted me with usual warmth and great coffee. Rich gathered up the morning paper

and showed willingness to leave Jim, Tammy, and me to a private conversation. I assured him that I wanted him there, too.

At last, Bob's diagnosis was shaken out of secret into sputtering words, sentences, and numb silence. It is still difficult to accept the enormous relief I felt by sharing such gut-wrenching news with its expanse of reality and ramifications with the nearest and dearest to Bob's heart—his children. Over the years, they had careened through other such news and ramifications. They knew each other well, made especially clear to me by Jim who broke the silence. "Dad just wanted to protect us, Fran. He just wanted to protect us." With my choice to no longer respect Bob's wishes, the roles would be reversed—now they could protect him along this journey.

There was nothing more to say and I wanted to give them time and space to process this news in their own ways. I hurried home before Bob woke up. As soon as he did, the ordinary acts of love took on a deeper meaning. I helped him sit up in bed, gave him a hug, scratched his back, cleaned his glasses, dressed him, pulled a pair of his fun socks on and then the shoes, combed his hair, handed him an ironed handkerchief and helped

him up for breakfast. Over coffee I confessed that I had told Jim, Tammy and Rich about what was going on with him. He reached for my hand and pulled it up to cover his heart and I placed my head on his shoulder.

## Chapter 15
## I'm By Your Side

******

*If our sense of who we are is defined by feelings of neediness and insecurity, we forget that we are also curious, humorous and caring. We forget about the breath that is nourishing us, the love that unites us, the enormous beauty and fragility that is our shared experience in being alive.*

**Tara Brach**

******

Bob's modus operandi was adhering to a strict routine and focusing solely on one thing at a time. My M.O., on the other hand, was spontaneity and multi-tasking. Pre-Alzheimer's, we periodically amazed one another and acted in

ways that led Bob to laugh and say, "I am turning into you; you are turning into me!" My comeback was, "Aren't you glad we married such nice people?"

I continue to be glad that I married such a nice person and that he showed me the ins, outs, and benefits of a strict routine and the rewards of working with a single focus. Living in the mystery of Alzheimer's, I found that Bob became my single focus. The disease demanded it. And with such intensity of focus, maintaining a strict routine became my coping skill. As Bob became more childlike, I often thought of my grandmother whose sole parenting lesson was, "Children do not need discipline; they simply need a good schedule."

Mid-morning Bob would begin to stir and our routine began. Singing, like I did to my young daughters, "Rise and shine, and give God the glory, glory…, the glory, glory" made for sweet hugs and his morning back scratch. His change of clothes was not complete without cleaning his glasses (honest to goodness, how do glasses get so filthy?), placing a handkerchief in his right hand, and giving his comb-over a light brush.

Spotlights kept illuminating the realities of *our* disease (like alcoholism I came to understand it as a family illness).

One day Bob was visibly frustrated. He kept saying, "The Rangers are off."

I agreed that indeed the Texas Rangers baseball team was having a crappy year.

"No! No! No!", he insisted and again repeated, "The Rangers are off?"

I took another angle, "Do you want me to turn on the television so we can watch some baseball?"

"No! No! NO!" and again he said, "The Rangers are off." It pained me to see him so frustrated and not be able to comprehend what he was meaning.

"Bob, show me what you mean?"

Relief spread across his face and enthusiasm put spring in his steps as he led me to our grandfather clock. Like a finally understood child, he pointed to the clock, "The Rangers are off?"

Oh my God! He was showing me that the weights were at the bottom and needed to be pulled up to power the clock. "Yes," I replied, "The Rangers are off. Let's get them back on track."

The combination of daily routine and reality planted seeds in the soil of my heart that grew into cravings for some type of a break. I was not picky. It could be a short trip to see something new, an opportunity to breathe fresh air, or a chance to eat food I did not prepare. Ideally, the food would be on a set menu that I would not have to make a decision. I learned over the months and years that constant decision-making will flat-out dull the spirit of life.

As an illustration that God knows the secret contents of our hearts and that God *"is able to accomplish abundantly far more than all we can ask or imagine"* (Ephesians 3:20, a portion of my all-time favorite scripture, Ephesians 3:14-21), within a short span of time, I was surprised and overjoyed to be asked to officiate at not one but two destination weddings, one in Boulder, Colorado another in Hershey, Pennsylvania.

The thought of escaping from the Texas August heat to participate in the jubilation of marriage celebrations, to relax and enjoy the cool Colorado scenic vistas of Boulder's Flatirons and the Rocky Mountain National Park was both intoxicating and life-giving. It had been way too

long since we had taken a trip not destined to attend or participate in a funeral.

My optimistic nature had lulled me into a false confidence about Bob's abilities to navigate through airport security checks, terminal elevators and trains, and courtesy buses. And in all honesty, I possessed a false confidence in my own abilities to maneuver Bob, juggle our luggage, and drive out of the Denver airport—the largest in the U.S. by land area and the fifth-busiest in passenger traffic. Our saving grace came from lessons I had learned after years of traveling with Bob which is to allow more than twice the amount of time *you think* is needed for every step along the way.

Once in Boulder, our time was fairy-tale magical and moved like a patient, kind, spiritual mentor. Every second, minute, and hour seemed to become three dimensional. We were *in* time and it was beckoning us to slow to a stop, see the wonder within crowds of people where not a single one was in a hurry, breathe in the freshness of the mountain air, and exhale staleness. As part of the wedding party we stayed at the elegant, which is an understatement, Hotel Boulderado. It's a short walking distance to the Pearl Street Mall,

accurately described as *"nestled between the mountains and reality."*

Bob and I strolled along the brick pathways to the outdoor retail gathering place. We found a *"perfect"* bench for sitting, and I dashed to get us a cup of ice cream *"to share."* The words in quotations *mark* memories of smiles and laughter in our relationship. Bob had a theory that only women used the word *"perfect;"* whereas, men used words like excellent, great, or super. Truly, it is interesting to notice his theory proven correct over and over again. With each *"perfect"* we would share a smile—one of those open and intimate smiles couples share when there is an inside story, a just you and me way of knowing, and a history in relationship. Along with the smile, I'd raise my pointer finger into the air and make a check mark of recognition for his theory.

One way of knowing me is that I enjoy sharing portions of food not only with the people I love but also with casual acquaintances, which is sometimes quite embarrassing to the former group. There is something in the sharing that gives the moment a sense of holiness, makes the food taste more delicious, and decreases the cost and calories by half. Bob graciously accepted that part of me

that made the breaking and sharing of a cookie a sacramental moment. He especially took delight in a year's ago McDonald's advertisement that showed a precious little girl sharing French fries with her sibling sitting in a high chair. The little girl would place a fry on the chair tray and say, "One for you," and then pinch together a couple of fries and say, "And two for me!" Bob often teased me saying that the little girl and I had identical and *"perfect"* ways of sharing.

We sauntered to a trendy restaurant located in the Pearl Street Mall for the rehearsal dinner. The highest form of entertainment at such affairs is to simply watch the betrothed couple, their parents, and the smart, successful and beautiful group of invited friends. Bob was known for saying, "God comes to us out of the future, picks up the pieces of our past and weaves them into a meaningful present." He didn't have rehearsal dinners in mind but it turned out to be an appropriate way of describing an event that weaves together future promise and long-ago memories.

This theological truth took a different twist for Bob and me that evening. The party crowd and commotion was too much for Bob to handle so we

found a table on the porch. The evening was Colorado perfect (check one for Bob) and to top it off Judy and Bill Burnett, Bob's admired and trusted general practitioner, joined us. Bob appreciated Bill's approach to medicine, his easy-going, quiet manner and his love of baseball, especially The University of Texas baseball. Their pleasant company and understanding of Bob's Alzheimer's was nothing short of kindness personified.

On our way back to the hotel Bob remarked on how much he had enjoyed visiting with Bill. Then he said, "But who was that nice woman with him?" A jolt of reality. Heart sink. Prayer.

## CHAPTER 16
## Estes Park

\*\*\*\*\*\*

*Grandeur and sublimity, not softness, are the features of Estes Park.*

**Isabella Bird**

\*\*\*\*\*\*

Reveling in the anticipation of a mountain-high dream, I decided to extend our stay by traveling to Estes National Park. When we got to the hotel we were given a room that had a view of the parking lot which an air conditioning and heating unit that did its best to hide. My disappointment was the color of the newly poured asphalt. With grace-filled assertiveness, I made a bee-line to the front desk. After making eye contact

with the receptionist, I began: "I want a moment of your time and your consideration. The room given to us will not work. Here's the deal (a phrase I was unaware that I use when I mean business until it was noted by a former co-worker). My husband has Alzheimer's so we will be staying in our room a majority of the time. This is probably the next to last vacation we will ever have; therefore, we need a room looking out on Lake Estes, not the parking lot. I will pay whatever it costs."

"Let me check if we have availability," responded the young man.

The suspense was gut-wrenching. The amount and speed of tumbling thoughts that enter one's mind in less than a minute is incalculable. "We came this far for a crappy room? Please, God let there be a room! Calm down. Don't cry. If Bob didn't have Alzheimer's, we still wouldn't want to stay in this room. Who would?"

"Well, we do have a room overlooking the lake that will be ready later. It is $80.00 more a night," was the final report.

"Thank you! Thank you! Thank you! Put the difference on my card. In the meantime, we will grab a burger. Thank you! Thank you! Thank you!"

We found a local spot that looked inviting located next to a stream of the mountain waters and were seated at a rustic table for two. I can still see Bob's eyebrows quizzically rise when I ordered a beer. We simultaneously broke out in laughter and reached out for each other's hands. I marvel and miss the precise timing of living and loving Bob. He was a believer and herald of "It's all about timing of things."

We found joy in reminiscing the surprising and often providential moments of timing in our lives—

> *Each of us separately discerning and ultimately dismissing a move to Richmond, Virginia in the winter of 1989. Could the backdrop of our love affair have been in Richmond rather than Austin?*

> *Jim, Bob's son, moving out of their apartment to Albuquerque, New Mexico, to work on his PhD in the fall of 1991. Did that move, leaving somewhat of an empty space in Bob's life, change his view of future possibilities?*

> *Bob's election and six-month sabbatical to serve as Moderator of the Cumberland*

*Presbyterian Church and my graduation giving us time together and space away from the seminary. How could we ever express appropriate and deep gratitude for that time?*

*The countless times we came from different directions through Dallas traffic only to wind up at the same moment in front of our garage door. Surely, that is not humanly possible, is it?*

*The unspoken, on cue spontaneous kisses, squeezes of hands, glances across a crowded room, sighs too deep for words, outbursts of laughter, removing of clothes that spoke volumes of understanding, unity, and passion. Yes, I marvel and miss these and other times granted to us and I trust to others who are deeply in love.*

When the last bit of burger and bun grease was wiped away and the final bubbles of foam were swallowed, we went for a walk to wait for our room. As we rounded our first corner of sidewalk we ran into a family who enthusiastically greeted Bob with hugs and exclamations of joy at

the *"timing"* of such an encounter. I did not have a clue as to who they were and I could tell that Bob was doing his dead level best to cover up that he didn't recognize them. After exchanges of conversation, it was clear that they were members of First Presbyterian, Dallas, and that they were devoted fans of Bob's leadership, preaching, and sense of humor. They spouted off story after story of times shared with Bob. With each of their recollections, Bob's countenance beamed brighter and brighter.

Over the years, I had grown accustomed to people knowing Bob and simply nodding with smiles after I introduced myself. Yet this time was different because Bob was not able to tell me who they were. The slight awkwardness and personal sadness I felt about Bob's cognitive abilities was out-shined by the clear fact that Bob was recognized, fondly remembered and deeply loved.

The rest of the week was equally shining! We cuddled up and sat on the hotel's balcony and watched the mountains and clouds reflected on Lake Estes. We walked along the lake trails, visited the famous Stanley Hotel and drove along the Trail Ridge Road, the highest continuously paved road in the United States reaching its highest point of

12,183 feet. The altitude caused our spirits to soar and literally with each breath taking we were awed by the majestic beauty surrounding us. I was heartsick that it was time for us to go home.

# CHAPTER 17
# Descent

\*\*\*\*\*\*

*If you're going through hell, keep going.*

**Sir Winston Churchill**

\*\*\*\*\*\*

Once home, things plummeted. Bob struggled with each breath. He was dizzy, nauseous and unable to stand on his own. Our eyes communicated unspoken panic. Ignoring public service announcements about calling 911 when a heart attack is suspected, I helped him to the car and drove to the emergency room where his cardiologist practiced. A quickly administered EKG gave assurance of no heart attack. Yet, what

was going on? At the end of two IV drips, a long line of questions, and all of God's given daylight, we received the diagnosis of altitude sickness. The doctor quipped that the only cure for altitude sickness was to go back to Estes Park and slowly drive home. When I did not respond with laughter, he suggested we follow up with Bob's cardiologist.

Little did I know that the ER visit was a prelude to the *"Week from Hell."* The next day, Bob had his six-month check-up with his neurological psychiatrist. Tears welled up as I explained about the day in the emergency room and the diagnosis of altitude sickness. The psychiatrist agreed and added that Bob also may be at a downward slope in the disease. From experience, the psychiatrist had seen that persons, especially highly motivated academics and CEO's, revealed similar patterns. They would do exceptionally well for an extended time because they were accustomed to mentally pushing themselves but at some point they would dramatically decline.

This vision of possible reality evoked a greater measure of soft tears to flow. I perceived that the doctor reacted to my tears with compassion and nervousness. "I highly encourage

you to visit with the Alzheimer's Association representative who offices just down the hall. Are you willing? Do you have time?" asked the doctor in a hurried sort of way.

I felt like she wanted my tears, more than me, out of her office as quickly as possible. "God," I thought, "this doc has a terrible job and must need to keep on a purely clinical level to function." In order to be transparent with families, there should be a sign on the door, "No shirt, no shoes, NO EMOTIONS, no service here."

"Sure," I responded with resignation. The staff arranged for Bob to sit alone in the waiting room. I assured him that it would only be a few minutes. I made my way into the rep's room, where upon tears poured forth in direct proportion to my tension and stress they were releasing.

I was handed a box of tissues as the representative said in a condescending way, "Your husband will handle this situation based on how you handle it. I recommend you read *'Radical Acceptance: Embracing Your Life With The Heart Of A Buddha'* by Tara Branch." Now, not only was I tense, stressed, and crying, I was also sorely vexed!

In all fairness, the rep had no idea that Dr. Ralph Underwood, my seminary pastoral care

professor, had instructed us to never hand, push or suggest a tissue to anyone crying because it sends a non-verbal message, "Dry up. Your tears are making me nervous." Of course, caring professionals keep a box of tissues visible and trust that a person will get one if wanted.

Also, she had no knowledge that I had read and re-read chapters of the recommended book. She could have asked, however, if I was familiar with the book since she suspected that I had not radically accepted Bob's Alzheimer's and our new way of living. "I already have that book in my Kindle and I will take your suggestion and revisit it," I curtly responded in perfect cadence with my steps as I got the hell out of her office.

Our ER visit was followed up by an appointment with Bob's cardiologist. He reviewed Bob's chart and checked him over. Then he sat on his stool for a quiet moment with his hands folded in his lap, as if in prayer. As if moved by The Spirit, he stretched out his leg like an oar on a linoleum sea and rowed over to me. We were eye to eye — the compassionate and knowledgeable eyes of a doctor staring into the eyes of weary and scared spouse who adored her husband and in a sympathetic and steady voice he said, "Do not

bring your husband back to me. When I first began treating Bob, his coronary condition was of utmost importance. Now Alzheimer's has taken its place. If you brought him back and there was something wrong, I would be ethically required to treat him. And for what kind of life?"

His words sunk arrows of radical acceptance into my heart. "Thank you, thank you for being so direct with us. You have renewed my respect for the medical profession," I responded. Bob was dutifully sitting on the examination table bewildered by the scene. I hugged him with years of past and future love and said, "Bob-Bob, (the name which our grandchildren christened him) let's go home."

# Chapter 18
# Getting Help

******

*From what I've seen, it isn't so much the act of asking that paralyzes us — it's what lies beneath: the fear of being vulnerable, the fear of rejection, the fear of looking needy or weak. The fear of being seen as a burdensome member of the community instead of a productive one. It points, fundamentally, to our separation from one another.*

**Amanda Palmer**

******

It was determined that Bob needed to have a cataract removed. If he couldn't think clearly I at least wanted him to see clearly. Thank the Lord for modern technology that has greatly improved the

recovery process. After the quick procedure, an aide assisted Bob into a wheel chair and rolled him to the car. After buckling him up, he broke into a big, always beautiful, smile and said, "Do you know what that nurse said to me?"

My curiosity peeked on several levels—for the first time in a long time he was initiating conversation and I was eager to hear what the nurse had said that caught his enthusiasm. He lowered the sun visor, opened the mirror, and with childlike wonder announced, "She said that I had the most beautiful blue eyes!"

I don't know what it feels like to be hit in the chest with an inflated airbag; however, in that moment I had a damned good idea. I am not sure whether my brain was sending rapid-fire messages to my heart or vice versa but sound waves reverberated loudly "Recover, respond! Yes! Yes! You do have the most beautiful blue eyes! You always have!" I choked. Bob looked again into the visor mirror and said, pleased as punch, "Well I never knew that!"

Questions pummeled me from professionals and acquaintances who thought it best *for me* to place Bob in specialized day programs designed for individuals with Alzheimer's or other

dementias. "Does Bob like to dance? The women who participate really like a new man to dance with," asked more than one person.

"No, he doesn't like to dance," I responded.

"Does he like to play like dominoes? BINGO?"

"No," I said. Thinking to myself, "He likes to read, write, preach, play with grandkids, and watch sports, all of which he can no longer do."

Exasperated with all this advice, I unloaded on Mary Rixford. "Everyone keeps telling me that I need to put Bob in an adult day care or get some help because it would be so good **for me**. No one has said that it would be good **for Bob**. If someone could tell me how it would be good for Bob, I might consider."

"You won't be dead," she said.

"What?!"

"You won't be dead. A Stanford University study showed that 40% of Alzheimer's caregivers die from stress-related disorders before the patient dies. That wouldn't be good for Bob," she said.

"Oh," was all I could say. We sat in silence as the new paradigm began to sink in.

Once home, I began researching several programs. Promotional pictures showed adults

engaged in line dancing with some men and women wearing hot-pink feathered boas, participants petting a visiting pony and others working on art projects. The pictures filled me with more despair and confirmation that Bob wanted to be at home and wanted most for me to be sitting beside him.

A convergence of providence, prayer, and friendship occurred when Amy Moore dropped by for a regular visit. That day had been particularly difficult so the first thing out of my mouth was, "Will you be on the look-out for a person who would be able to stay with Bob for a few hours each week? I've got to have some help."

"Tom could do that if you wanted him to," she said.

Tom is Amy's oldest son. Every fiber of his being (no exaggeration!) was what our family needed — kind, caring, dependable, quiet, understanding, intelligent, faith-filled, adept in the kitchen, and even an amateur magician who filled our grandchildren with wonder. He intuited Bob's needs and desires with aplomb while pursuing his dreams of acting and a degree in nursing. Bob alternated as a sounding board for Tom to practice his lines or a silent encourager when he needed to study. After watching his skills caring for Bob and

applauding his talents as Dr. Frank-N-Furter in ROCKY HORROR SHOW (MUSICAL), it's a tossup as to where he will be most recognized and appreciated.

Tom helped me learn that I could leave Bob for stretches of time and that I benefitted from the measures of mind, body and soul recreation. I decided to be open to the idea of seeking additional help. While slickin' up the house before Gloria, our housekeeper, came to clean, I opened our gallimaufry drawer and raked in counter top clutter. There, just as I had left it a good three years prior, was a pamphlet advertising an in-home-care company. Still believing that our living God sends signs, I called to sign us up.

We enlisted their help. The first batter out of the box didn't last long. With my right arm and pointer swinging outward, I yelled, "Strike!" because Bob was left lying in feces for several hours. When the next batter stepped up, I verbalized sternly, "Strike!" because Bob was repeatedly goaded in my presence with verbal exaggerations of, "Don't you hit me. Don't you hit me."

Third up (either because of my persistence or desperation) was a shining star, Sharon. She was

a female version of Tom. She too had a dream—becoming a mom and becoming a nurse. She didn't want to call me when I was out and about; however, she knew that Bob wouldn't let anyone else clean him up if he couldn't make it to the restroom. Sharon and I were a great *"Clean Team."* I would clean up Bob and she would get the floors and begin the wash. One afternoon, she was giddy when I got home. She reported, "Bob, said 'thank you' to me when I helped him lie down for a nap!"

Another unexpected source of help came when Kris Crawford, a seminary classmate, asked if she could stay with us while she and her husband, Stan, transitioned vocations and homes from Shreveport to Dallas. Little did we know that she was going to help us transition to the next stages. She brought Bob a cookie-a-day which lit up his face with smiles. Together she and I came up with a tried-and-true plan of lifting Bob from his more frequent falls. After he was off the floor, I'd tell him, "You made an A+!" This was my grading system which meant his fall left no blood, no cuts, no bruises.

# CHAPTER 19
# Getting Lost

******

*Have you ever walked along a shoreline, only to have your footprints washed away? That's what Alzheimer's is like. The waves erase the marks we leave behind, all the sand castles. Some days are better than others.*

**Pat Summitt**

******

The long and winding road of decline led us to a place where our routine of activities was no longer feasible. Our daily four-lap-walks around the mall were reduced to three, then two, down to one lap. Our quick strides to the second-floor family restrooms eventually became mad shuffles (not always successful), as the disease progressed.

After treating ourselves to a late lunch on the first floor of the mall, Bob needed to find a urinal. We got to the MEN'S in time and he went in alone. I decided to make a quick visit to the WOMEN'S and wait for him. He never appeared. As other men came and went, I called out his name—no answer. Panicked, I asked a man, "Would you **please** go check every stall to see if my husband is there?" No husband. I rushed across the hall to the security office to report Bob missing. The security officer explained that it would take a while to find him because the mall was so large and then asked, "What hand does your husband write with?"

"What?!" I asked incredulously.

"I recently learned something at a program about Alzheimer's," said the officer. "People usually turn the direction of their dominant hand. What hand does your husband write with?"

"His right," I said remembering the neuropsych evaluation that included *"right-handed."*

I called Sharon Balch and said, "Bob's lost. He wandered out of the bathroom at the mall. I was sitting right outside the door. They're looking

for him but they said it would probably take a while. Why don't those security cameras help when you need them?"

"Where in the mall are you?" I'll be there in a minute," she said.

"No, it's okay. Just **please** pray that they find him—quick! And that he hasn't wandered into the street," I said. Pleading hopes kept time with my racing heartbeat.

"We've found him," crackled the officer's voice over a walkie-talkie in the security office. "We'll be there in a bit."

Relief and gratitude surged through me as I waited for Bob and the officer to make their way back to the office. Finally, they strolled up like a pair of high school buddies. When Bob caught my eye, he ducked his head and sheepishly grinned. I raced to give him a hug. The officer relayed that Bob had indeed taken a right turn, gone outside the first floor and somehow managed to get to the second floor in another area of the mall. So much for mall walks.

Monthly massages and pedicures that Bob had enjoyed also came to an end because he became too agitated. It became impossible for him

to maneuver sitting in a barber chair so Yolanda, his barber, came to our home to give him a beard trim and *"hairs"* cut. Bob's appreciation for preciseness led him to say, "I got a 'hairscut,'" instead of haircut since more than one hair was cut.

Bob's limited speech was heart-breaking to me and more than likely for him, as well. His vocabulary consisted of "yes;" "no;" (not always the correct answer) and "shit, shit, shit" (probably always the correct sentiment). Personal hygiene no longer existed and was even fought. Once while cleaning him up in our walk-in shower, he became frightened by the water hitting him which led him to become furiously combative. He yelled, "Shit, shit, shit!" I grabbed hold of his chin and look directly into his eyes and said, "I see the face of Christ in you and I don't believe he would say, 'shit, shit, shit'." With that, Bob began laughing in his former fashion; then *we* began laughing and finished our shower.

One hot summer afternoon while headed to Bob's doctor for a yearly exam, we were stopped in a mile-long line of traffic while waiting for first responders to tend to auto-accident victims. The

accident was where South Buckner Blvd dead ends at East Northwest Highway (some experiences are tick-tock-locked in memory). Bob was frantic to go to the restroom. At this quasi-cardinal point, I made the decision to place Bob under the care of Faith Presbyterian Hospice. I didn't want him to go through another experience like this and I didn't know how long *"Lady Luck"* would be with us in his excellent general health and ever-increasing falls and agitation.

I texted our children and said, "I'm getting Bob on hospice not because the end is near but because the road is long and we need their help."

Jennefer Dixon is the music therapist at Faith and our personal Anne Sullivan miracle worker. With her charm and talent, she got non-verbal Bob to sing! At her second visit she exclaimed, "You harmonize! You held out on me last time." Listening to them conjured up a performance Bob and I saw by Van Cliburn where he said, "If scripture is the Word of God then music is the breath of God."

She made a special appointment around Christmas to come and sing with Bob and our grandchildren, Isabella, Kaya, Trey and Stax. She

let them strum her guitar, ask questions and make special requests to sing along with Bob-Bob. Isabella requested, *"Have Yourself A Merry Little Christmas."*

As we sang, I understood why Judy Garland originally told song writers Hugh Martin and Ralph Blaine that she refused to sing it because it was too sad. But the producers of MEET ME IN ST. LOUIS, persisted, "No, no—it's a sad scene, but we want sort of an upbeat song, which will make it even sadder if she's [Judy] smiling through her tears." We sang and we smiled through our tears.

After the New Year, Joan Curtis and I got together to enjoy conversation and Mexican food. Before the empty plates were taken away, I received a call from my physician's assistant. She reported that results from Cologuard (a new, at-home cancer screening test she had prescribed for me) had arrived on her desk showing *positive* for colon cancer. I stepped away from our table and said, "You need to understand that my daughters' father died less than three weeks ago from colon cancer and other complications. What do I need to do? I want to do it quickly—remember my husband has Alzheimer's."

I blurted out the news to Joan. Interestingly, I didn't want to tell my children—for the *first* time I understood Bob's thoughts about not wanting to share disturbing news. After visiting with Joan, I still needed to process the news by talking it out. I called Mary Gail Stinnett my best friend since elementary school. She insisted that I tell our children, especially since I had been so upset about Bob *not* telling. Rick, her husband, had begun *Googling* and he got on the phone saying, "Fran, let's stay calm. There's a 13% false positive rate."

Exhaling a small sigh of relief, I inhaled a big dose of reality—I could not care for Bob if I had colon cancer. I visited one long-term care facility and decided it would be an even long time before I moved Bob there. Nurses were advocates of group homes for Alzheimer's patients so I began exploring that option. I visited one that was managed by a woman who personifies kindness. She listened, asked questions, and then regretfully told me that she could not put her other residents in danger since Bob was becoming more aggressive.

Several weeks later, out of the blue, she rang our doorbell. She said that she couldn't get us out of her mind and still couldn't have Bob as a

resident but she wanted to meet him. As the three of us visited, I explained to Bob that I was looking for places where people were more experienced than I in taking care of him. Bob picked up that my emotions were tender. He hugged me and we both cried.

I redirected my anxiety about possibly having cancer to continuing the search for an exemplary living arrangement for Bob and I believed I had found it. In the midst of worrying about how I would get Bob moved, Mary Gail called and said that she and Rick were coming Dallas. She asked, "Do you have some ideas about what Rick can do while I'm in training sessions?"

I suggested several options but none of them seemed a fit for Rick. Then a brilliant idea came to me, "Would Rick be willing to help me move Bob to the group home? I know that he's done that with his mom and I really need help."

"Absolutely," she said.

Rick arrived on *"Moving Bob Day"* since I had already taken his personal belongings and decorated his room with familiar and favorite things. Bob was happy to see Rick and a little less happy (but willing) when we got in the car. I sat in the back with Bob while Rick and I engaged in

light conversation. Upon arrival, the staff opened the door and said, "Good morning, Dr. Shelton!" It had been awhile since Bob was professionally addressed and it delighted him.

We sat at the dining table with Bob and other residents while they ate lunch and then we left. As soon as we got to the car, Rick's eyes welled with tears. He was well acquainted with his mother's and a neighbor's journey with Alzheimer's, and he said, "Let's say a prayer" and thankfully he began.

Jim had already planned to drive up for the weekend because I was scheduled to facilitate a Faith & Grief Ministries retreat, *"Hope & Comfort on the Journey of Grief."* He, Tammy and Rich stayed with Bob during the days and they were pleased with the way Bob was adjusting and with the staff.

One evening after I'd been with Bob for the day, Sarah asked me, "Mom, do you think Bob knows you?"

"Well, I hope so! His hand was down my shirt and he kissed me."

# Chapter 20
# Friday

\*\*\*\*\*\*

*Does the resurrection free us from thinking of the cross as it was before the resurrection? To answer No is to say that this is a story which (much) be told and heard, believed and interpreted, two different ways at once – as a story whose ending is known, and as one whose ending is discovered only as it happens.*

**Alan E. Lewis**

\*\*\*\*\*\*

On the upsweep of high noon, eight days after Bob began living in a group home, he was unresponsive. Tammy discovered him in this state when she had stopped by for a visit. She asked aides if they had called me or hospice and the

answer was no. She moved into action by calling me and instructing an aide to call hospice.

As an illustration to me that God always has our back *and* goes before us, Amy Moore happened to be visiting me in my home that Friday morning. Her presence of grace upon grace was everything more and nothing less than an embodiment of the Holy Spirit's ushering in to guide and direct me to be with Bob in what would be his last days. She followed me as I rushed to his side, hoping to rally him to a higher level of consciousness.

Such a rallying miracle did not take place despite all my coaxing, kisses, and words of love. Instead, it was Bob's words, spoken years before, that rallied me from the depths of panic, despair, and sadness into a surrendering peace.

In late January of 2008, my mom's health dived to a new level of deterioration. Bob had said to me, "It is time. It is time for your mother to die."

"How dare you say such a thing about my mom," I said.

"How DARE," I repeated with greater decibels and force. Whereupon he tightly hugged me as we stood swaying back and forth until my

sobs subsided. Still embracing, he softly repeated my name as if it were pure poetry saying,

**"Fran, Fran, Fran there comes a time to die."**

His former words were like a marinade that washed over, soaked into and tenderized my present shock, sadness, and adrenaline. Amy, Tammy and I held Bob's hands as Amy offered a prayer. I remember giving thanks for the power of prayer, touch and friendship. Each one of the powers is an unmerited gift. And yet the combination merges to become a blessed trinity that grounds us on earth and connects us to heaven.

Amy's prayer also prepared us to hear the hospice nurse report that Bob was actively in the process of dying. I dogged her with questions and she ushered Tammy and me out of Bob's room. I pleaded with her to give it to us straight, "We are strong women. We can take it."

She hemmed and hawed for a bit and finally said, "He probably has 24-72 hours."

With the words spoken, I began questioning my strength. Could I take it? Take the reality of it all—the cursedness of Alzheimer's and the reality

of his death? As a means to scaffold our inner beings, Tammy and I began calling family.

Months earlier I had imagined such a time as this and had asked Omi and Sarah if they wanted me to call their husbands, Robert and Ken, to break such news or to call them directly. Omi responded first, "Call me. I don't think Robert could take it." Sarah concurred about Ken.

I was grateful that I had asked so that I didn't have to waste time wondering. Each of them wanted to drop everything and get to Dallas so that they could see Bob and we could all be together. I discouraged them because their dad had died two months earlier and their hearts were heaping with raw emotions. In some level of denial I said, "Let's hold off and see what happens. I'll stay in touch."

With the presence of Rich, who thankfully was working in town, and Jim and Diane who flew on four wheels from Austin, Tammy and I felt comforted and grateful for the connection of family. Instinctively, sometimes with words and more often without, we gifted one another with both private and collective time with Bob. The holiness and harsh reality of such time is pregnant with silence, a collection of unrelated fragments, or Morse code of sighs and still deeper sighs.

Hymns whispered their sound words and melodies in my ears and become prayers. Late Friday afternoon, I kept hearing "the distant triumph song" from "For All the Saints," The [Alzheimer's] "strife is fierce,...long" [yet with loving support] "hearts are brave again, and arms are strong. Alleluia! Alleluia!"

Watching the tenderness extended to Tammy by Rich and to Jim by Diane, I recalled strands of stories of how each couple got together. It took great and authentic forces of *LEPP *(Ludus, Eros, Philia, and Pragma)* to round out the established S*torge,* or familiar love that bonded Bob, Tammy and Jim especially after Barbara's death.

Bob took delight in pointing out that it was Tammy who forecasted changes in the family dynamic by announcing, "Well one of us will get married." It was important to Tammy that her dad and brother would feel affection for and connection with her spouse; therefore, it was with confidence that she introduced them to Rich Mackesey. It was equally important to her for them to remember that his name was RicH, not RicK. Of course, sometime during the first meeting, Bob mistakenly called him RicK.

*L-Ludus, playful love; E-Eros, sexual love; P-Philia, affectionate love; and P-Pragma, enduring love.*

We knew that Jim had to be love-struck with Diane and her daughter, Natalie, when he traveled to North Carolina for Thanksgiving rather than being with us for the Shelton traditional feast. We marveled that Jim was willing to forgo Rich's turkey and dressing, and even Tammy's cherry pie made especially for him. Still, we had no idea of just how deeply in love Jim was until we learned that the Thanksgiving table in North Carolina had a bounty of blue JELL-O and a rendition of unrecognizable chicken. Wow, this relationship must be serious!

We were all excited about finally getting to meet Diane. Tammy flew in for the occasion that took place over dinner at El Azteca in Austin. There, in our family's favorite haunt, Jim announced their engagement. In his quiet and trusting way, he shared that we would unequivocally love Diane because *he* loved her.

I found it intriguing that Tammy and Jim had somewhat different processes of thinking about their lovers and their family's welcoming of them. It also made me aware that Bob and Jim had similar viewpoints as evidenced by Tammy's question on the way home after meeting Diane. "What is it with you men? You introduce me to

your significant others at the same time you tell me you are going to get married?"

Tammy spent the first night with Bob scrunched up on the love seat that we had moved from home to give Bob's room its own sense of home. For light in the darkness of unknown, powerlessness, and sadness, she picked up Bob's Bible that she had given him years before and read the book of Esther. Her selection was prompted by the sermon series that her pastor, Dr. Perryn Rice, was preaching. This book's well-known phrase was playing out in real time, *"for such a time as this,"* the coming together of feelings for Bob from our different relationships, experiences and perspectives filled his room with love.

Jim and Diane spent the night with me so that I wouldn't be alone. I knew *"for such a time"* was coming and I was grateful that it didn't have to begin in the darkness. Although I had spent many a night alone throughout our marriage, there was sense that the very walls of our home knew that this night was different. As I curled in a fetal position between the sheets, the pendulum's rhythm from our grandfather clock kept time to silent songs of lament from all the memories crowding our bedroom.

*Day is done, but love unfailing*
*Dwells ever here;*
*Shadows fall, but hope, prevailing,*
*Calms every fear.*
*God, our Maker, none forsaking,*
*Take our hearts, of Love's own making,*
*Watch our sleeping, guard our waking,*
*Be always near.*

**Day Is Done, verse 1**
**By James Quinn**

# Chapter 21
## Saturday

******

*The idea of the unity of opposites... .*
*God is day night, winter summer, war peace,*
*satiety hunger... .*
*It is necessary to know that war is common and*
*right is strife*
*and that all things happen by strife and necessity.*

**Alan E. Lewis**

******

Mid-Saturday afternoon I went for a walk. The neighborhood was marked with preambles of spring color. A patch of white daffodils caught my attention. I plopped down on the curb and gazed at their beauty, innocence and strength. Their ability to protrude out of the clay soil with such grace reminded me of a favorite quote of mine by

Hal Borland, noted New York Times journalist and author:

## No Winter Lasts Forever; No Spring Skips Its Turn.

The symbolisms moved me to a passionate and one-sided conversation with God that went something like this: "God, I *see* that Bob's death is similar to a birthing into eternal life but it's so damn laborious for him and for all of us watching. When a woman goes into labor, vital signs are monitored just as are Bob's. Yet when the crowning of head doesn't take place, after say 24 hours, very often a Cesarean is scheduled. Why can't there be a celestial Cesarean for this child, for this servant, for this beloved man? Why can't your canopy of sky split wide open and you pull him up into your arms? Why? It is agonizing to watch him labor for every breath, even when he does it in such a gentle and peaceful way. That almost makes it worse! No, I wouldn't want to see him agonizing. He is so kind and gentle. I feel so helpless."

Once again, in my state of agony, it was Bob's voice I heard. His prayer, in times like this,

was full of compassion and anger tinged with humor, "God Almighty, where's a good heart attack when you need one?"

The sense of helplessness we all felt was bolstered by phone calls from caring friends, prayers lifted by the faithful and visits from the brave. Each communication was a display of the etymology of *company*. From the Old French and Late Latin, it means "friendship, body of soldiers;" one who "eats bread with you." Their presence was akin to warm bread and butter that fed our hearts. The stories they shared filled the air with bursts of laughter that deconstructed the funereal ethos of the room.

Visits from two, The Reverend Dr. George W. "Hank" Hunt and The Reverend Walker Westerlage, particularly stand out because of friendships they have extended across generations of our families.

Hank's first call to ministry was out in the West Texas town of Fort Stockton, my home. My mom was overjoyed by his leadership and preaching, my sister served as his secretary, and I went through his confirmation class. I couldn't bring myself to join the church with my class because hesitations about hell played hopscotch

across my heart due to my Roman Catholic indoctrination. Nevertheless, on Hank's last Sunday before moving into his second call, I was called to officially join the church.

When Bob (who also had known Hank for years) and I moved to Dallas, it was terrific to reconnect with him and Regina, his wife. They were there for us during Bob's illness in a variety of ways—invitations to dinner, drop-in visits with homemade cookies for Bob, snail and e-mails filled with affirmations of their friendship and the ceaseless prayers.

**A Story Hank Shared**

When I was in the 8th grade in Lubbock, I formed a rock and roll band dubbed the Ad Libs. Over a short time, we gained considerable popularity in the West Texas/New Mexico area. That was due, primarily, to our exceptionally talented female vocalist, Ralna English, who was fourteen when she launched her career with us. She went on to have a successful career with The Lawrence Welk Show. It was mainly due to Ralna that the Ad Libs beat Buddy Holly and the Crickets in a battle-of-the-band contest at the Plaza Theater

one August Friday night in Lubbock, Texas. Catch an Ad Libs performance on https://www.youtube.com/watch?v=F5E8CJspbtU .

One of our more interesting performances was the night we provided warm-up entertainment for the speaker at a Lions Club convention at Lubbock's Hilton Hotel in 1957. The speaker was Senator Lyndon Johnson who was, at the time, majority leader in the US Senate. His table of honor was perpendicular to a raised stage on which The Ad Libs entertained during dinner. One of the songs we performed that evening was *When the Saints Go Marching In.* Each member of the band took at solo (piano, sax, guitar, drums, and trombone).

The last to solo was me. I stood up on my upright bass and balanced myself in the cradle for the solo. The men in the crowd were cheering mightily, so I became overly enthusiastic. Ignorant of the laws of physics, I told myself that when I completed the solo, I would jump straight up and then catch the bass on my way down. I jumped up and the bass shot straight out from under me and landed on the head table. The end of the bass came down on small dish of uneaten peach cobbler and flipped it up on Senator Johnson's white shirt.

Senator Johnson was known, among other things, for a somewhat ferocious temper and he did not seem to hold serenity in high regard. His face flushed fire engine red. But then, apparently, he realized how much the Lions Club conventioneers, who mostly consisted of his constituents, were enjoying the kids on stage. Accordingly, his nascent fury wilted into a rather weak, resigned smile. He took his napkin and wiped as much of the cobbler from his shirt as he could. Then he came on stage in his technicolored shirt, and made his speech.

After I graduated from college, I worked in Washington D.C. for our congressman, George Mahon. One day he invited me to the weekly Texas delegation lunch where lo and behold, I was seated next to Johnson, by then our vice president. I pretended we had never met and certainly wasn't going to pull out my standup bass. The luncheon passed without memory of the Lions Convention fiasco. Peach cobbler, incidentally, was not on the menu.

*****

Walker was a student at APTS the years leading up to Barbara's death. During that time, he

not only stood and sat by Bob through the grief and mourning process; he also stood and sat by Jim through it all. Walker's age, theological insights, humor, and interests served as a bridge that promoted understanding between the generations.

**A Story Walker Shared**

Will Campbell, minister, author, and notable supporter of civil rights in the Southern United States, invited Bob and two of his colleagues to a lunch in Nashville in the early '70's. The Committee of Southern Churchmen wanted to thank the trio for their collective desegregation work in Memphis. At the luncheon, they were given a silver-plated round plaque commemorating their brave disciple work.

When it was over, they headed back to Memphis under darkening winter skies. Soon it was sleeting and snowing. They decided to stop in this little town just west of Jackson that had a small restaurant known for its fried chicken, the best in the state, and take some home for their families. When they came out of the restaurant, there was a dog shivering in the wet cold. The dog's collar said

his name was Buck. It also had an address in Memphis close to where one of the preachers lived. So they loaded up Buck and the chicken in the car and turned for home.

The highway ~~was~~ became slicker, and, suddenly an 18-wheeler in front of them went into a jackknife. The truck's back doors opened and out started raining what looked like shoes.

Well for those who have ridden with Bob, you know he was driving faster than he should have been. He braked. The car started to slide and he had trouble bringing it to a stop. At last, when he brought the car to a stop, it was leaning at an angle toward the passenger side.

In all the chaos, the back passenger door opened and out rolled Buck and the chicken on the round plaque, followed by the fools in the car barreling down the hill after it all. After corralling both the dog and their supper back in the car and catching their breath, Bob, of course had the final word: "Isn't this so typical; three ministers chasing a chicken dinner and a buck when there are 200,000 soles scattered in the woods needing to be saved."

When I asked Walker if this story was true, he said, "The first part. Never let the truth ruin a good story. You can say that it is Apocryphal."

The gift of "New strength to sight" as promised in the below hymn led me to perhaps one of the crazier or perhaps saner things I did over the weekend. After trudging through a foot-deep accumulation of live oak leaves blanketing our yard and hiding our circular drive, I contacted our landscaper, Noemi Quillin. I wanted to let her know about Bob's condition, to seek her prayers and the name of an individual who could rake and bag. Of course, she had a "perfect" recommendation.

*Dark descends, but light unending*
*Shines through our night,*
*You are with us, ever lending New strength to sight.*
*One in love, Your truth confessing,*
*One in hope of heaven's blessing,*
*May we see, in love's possessing Love's endless light!*

**Day Is Done, verse 2**
**By James Quinn**

# CHAPTER 22
# Sunday

******

*Central to the good news in the Christian three-day story is its demonstration that death does not have the last word upon human destiny: that God sets limits to death, and to death's power to oppress and limit life. But this Sunday victory over death ... [also] is confirmation that the God who limits death also uses death to limit life.*

**Alan E. Lewis**

******

At four o'clock I awoke and felt a desire to be near Bob. In the starlight, I eased quietly into Bob's room. With the first whimper from door hinges in need of WD40, I realized that it was too early for Jim and Diane to rise and shine and it was too late for me to back out the door.

They roused out of the layers of comforters and we sat crisscross applesauce huddled around a picnic basket I had filled with breakfast goodies. In the pre-dawn of that Sunday the mystery of faith seemed tangible. I felt Christ's real presence with us in the breaking of blueberry muffins and in partaking of the cup of salvation filled with strong coffee.

### "A time for mourning, a time for dancing"

Henri Nouwen, Dutch Catholic priest, professor and writer, opened me to the understanding that "mourning and dancing are never fully separated. ...In fact, their times may become one time...without showing a clear point where one ends and the other starts." Our family marked this one unprecedented time by choreographing sequences of conversations with Bob individually, in pairs, and all together.

Omi fell in step with the dance when she arrived that afternoon. After her one-on-one time, Jim stepped in with fluidity and began singing Willie Nelson songs to Bob. With each sequence of spoken and unspoken good-byes along with half-hearted assurances we hoped to convince Bob, or

more importantly ourselves, that together we would faithfully carry on with profound gratitude for his love and the myriad ways he expressed such love.

Alone in the room with Bob, I crawled up in bed and snuggled next to him. I wanted to be able to hold on to him forever and at the same time I wanted him to move beyond the earthly constrictions of Alzheimer's and his inability to give voice to his deep thoughts and sound to his easy laugh. In the daylight of that moment, I became convinced that Bob could still read the contents of my heart. My conviction came through the flash of a memory filed away so many years ago, that I was startled to have it resurface with such speed and clarity.

With my head on his chest I heard Bob through conversation that we had in the past. We had made love and were silently reveling in the beauty and ecstasy of this God-given gift. My ear was over his heart and in the quietness, I said, "I hear your heart." In a flash of wit, he said, "Good! I'm glad!" and we both laughed.

Then he became solemn and held me tighter. He began telling me about a conversation that he

had with one of his dearest friends decades before. His friend had come to inform Bob that he and his wife were getting a divorce. Bob was dismayed at the news. Outwardly the couple appeared to have a happy and solid marriage. "Why?" Bob asked his friend. "For one primary reason", his friend replied, "I don't want to be in her arms when I die." At the story's end, Bob began holding me closer. He whispered, "All will be well. All will be well if I am in your arms when I die."

Shortly afterward, Tammy and Omi were also by his side. We marveled at the combination of strength and vulnerability; sacred and clinical; perseverance and surrender; sublimity and indignity; often associated with one's movement from life to death. And then there was a silence that I felt in Bob's hand and saw in his countenance. With an anxious heart and in a steady voice I said, "I think he has died. Please get everyone and an attendant."

In that void of time and space, Bob took a deep inhale. I learned that such a breath is often called the Lazarus reflex. As a witness, I observed this as sacred breath where a child of God attempts to simultaneously inhale earth and eternity. It was three o'clock on March 4th.

Each time I recall that date, I also am reminded of The Revered Dr. Blair Monie, a colleague in ministry for ten years. Each year, he would announce to the staff that March 4th was his favorite day out of the 365. When the eyebrows of new staffers rose with curiosity, he would give the command, "March 4th. March forth to do great things today!" My faith leads me to believe that Bob marched forth into eternity to do great things in a larger realm of service.

Months later Jim shared two memories tied to the end of Bob's life. "Fran," he said, "I liked that your immediate words were, 'Oh, Bob, you don't have Alzheimer's anymore.'" And, "As Diane and I were leaving, there was the softest of soft rain falling."

*Eyes will close, but You unsleeping*
*Watch by our side,*
*Death may come, in love's safekeeping*
*Still we abide.*
*God of love, all evil quelling.*
*Sin forgiving, fear dispelling*
*Stay with us, our hearts indwelling, This eventide.*

**Day Is Done, verse 3**
**By James Quinn**

# Chapter 23
# Things Will Never Be The Same

******

*You will never age for me, nor fade, nor die.*

**Will**
***Shakespeare in Love***

******

Sad, overwhelmed and exhausted, I longed to saturate myself with the outpouring of love and sharing of memories from our friends who had blessed us over the last several days. I believed such saturation would be the way to prepare myself and our family for the *"coming years, through paths unknown"* with Bob spiritually, albeit not physically, present. To accomplish this preparation, I decided we should sit on our patio,

breathe in the spring breeze, and pig out on the tostados, salsa and guacamole left over from the dinner Tammy and Rich had catered after Bob's memorial service.

Family members refrained from commenting about the strangeness of this breakfast menu. As we were devouring the chips like a sounder of swine, I bit down on a huge, hard hunk of avocado. "Wait a minute," I thought, "avocados are not hard and tostados are not this clunky-hunky. What in the world?" Before I knew what was happening, I spit out my 20+ year old bridge. My tongue swept across the length and width of a three-tooth interstate that felt big enough for a Mack truck to make a U-turn.

"Oh, no!" I shrieked, "My bridge fell out." In unison, *our* grandchildren sang out, "Let's see." I cocked my head and gave them a wide hillbilly grin. This gained me no sympathy. Instead, faces of horror, they gagged and shouted, "Gross! Do it again, Grammy."

I called *our* friend and dentist, Dr. Shahnaz Babaloui, and was in her office within hours. (I continue to use *our* rather than *my* when describing children, friends, home, favorite restaurants, etc. It feels natural and easy in the unnatural and difficult

transition to widowhood.) Before Shahnaz could assume the role of dentist, she was our friend full of sympathy. Bob came close to idolizing Shahnaz for he considered her one of the most beautiful women he had ever met and by far the best dentist. She, in turn, appreciated his humor and charm.

She made me a make-shift retainer, scheduled an appointment for me with an oral surgeon and gave me an outline of nine months of dental procedures necessary to give me back my smile and speech without a lisp. Thankfully, she did not put dollar figures by these upcoming procedures. That would've made me lisp and stutter.

My experience facilitating bereavement groups reminded me that for some mysterious reason, individuals who have lost a loved one seem to encounter another tragedy, or at least drama, soon after their initial loss. For examples: one friend fell and broke her hip; one buried his mother and his cat of 17 years within two months of his wife's death; and still another had to pack up treasures, junque drawers and essentials within three weeks of her husband's death because the *"sympathetic"* new owners, who had purchased the home during his short illness, were ready to move

forward with their lives. In these groups I had also cautioned against comparing one another's circumstances—sad is sad; bad is bad; hell is hell. "But shit!" I thought, "an honest-to-goodness hole in my head?"

## Chapter 24

# First Wedding Without Bob

******

*"i thank You God... for everything
which is natural which is infinite which is yes"*

**e e cummings**

(*natural infinite yes* – inscribed in Bob's wedding ring)

******

Less than two weeks after Bob's death, I officiated at a wedding in the Dallas Arboretum surrounded by 500,000 (give or take a few) blooming tulips, narcissus, hyacinth and Dutch Iris and hundreds of thousands of other spring flowers. Gazing at the floral beauty of pristine whites and petals of colors adorning this patch of earth prompted me to look into the bluest of skies

and wonder, "Is heaven this beautiful? Bob, can you see all these red (his favorite color) tulips? Or are you floating over Holland and taking in an entire country view of tulips?"

Walking with the couple to the wedding site, I could sense their jittery state. As we tiptoed through the tulips, each had a different sense of direction to the wedding site. Their polite, yet emphatic, give and take made me smile because I had planted a *"Bob Story"* in my homily that spoke about differences of opinions.

The story is that shortly after Bob was elected as APTS President, he had lunch with the Roman Catholic Bishop of Austin. While they were munching on bread sticks, Bob confessed, "Bishop, since being in the President's office, I've had to deal with letters full of complaints from donors, professors, and students."

The Bishop calmly balanced more butter on his bread stick and kept munching and listening.

"Tell me," Bob asked, "what in the world do you do when you get these types of letters?"

"Oh, Bob," said the Bishop as he nonchalantly waved his bread stick like a baton heavenward, "I don't worry over them at all. I simply respond something like this: 'Dear So and

So, You may be right. In Christ's service,' and then I sign my name."

On cue, the couple laughed. The groom interjected, "I wish you had told us that story as we were disagreeing about how to get here. I will remember and use often, even at work."

The couple's generosity for officiating at their marriage was a gift card to Season's 52. Never waiting for a gift card to get cold, I invited friends, Lana and James Self, and Janice Crawford to dinner. The five of us had gotten together regularly before and during Bob's illness for dinner, conversation and occasional hymn singing. James and Bob were peers, voted the same ticket, appreciated the secret mysteries of baseball, and served the church in the 1960's that made their catalogue of real-life stories entertaining.

I arrived early for the reservation I'd made. The host led me to a table elegantly set for six people. "I asked for a table for five," I said. Not trusting my math, and still standing, I began pointing to the individual seats, "There is Lana, James, Janice, Bob and me. Yes, we only need a table for five," I repeated.

Then the reality of Bob's death, his forever absence, swept over me like bristle brushes on a

parquet floor. I fell into a seat and whispered to the host, "Wait a minute. There are only four of us, only four. My husband recently died. He had Alzheimer's."

"I'm so sorry. That is the worst," said the host.

If I had a buck fifty for each time someone (stranger or friend) said to me, "Wow! OMG! Alzheimer's is the worst, THE WORST!, I could pay for the water heater part, dishwasher or the new air conditioning unit (all that have gone kaput since Bob's death). If you only take away one tidbit from this book, I pray that it will be this—when you hear devastating news about a friend, colleague, or family member consider saying, "This news breaks my heart. I admire (or enjoy, love, think about _____ (fill in the blank with the name of individual) when... (fill in the ... with one of your great memories."

I promise you that this is THE BEST! way to respond. Moreover, the individual's memory may be the first time the family member has heard that story or anecdote.

## CHAPTER 25
## Good News Bad News

******

*Relief is a great feeling.*

**Vera Nazarian**

******

At long last the appointed time came for me to have a colonoscopy. Tammy took off work to take me. Jackie, her mother-in-law and my heart-to-heart friend, joined us for moral support. My name was called in short order and I put on the hospital gown, by-far the easiest part of preparation for a colonoscopy.

Waiting for the procedure to begin, I visualized talking with Bob, yearned for an assuring squeeze of his hand and wished for a

chance to feel his mustache press against me initiating a kiss. Before I got to enjoy his kiss, I was awake in the room where I had changed. The nurse said, "Your procedure is over. As soon as you get dressed, please go to the conference room across the hall. I will get your daughter so she can join you."

Once we were together, I said, "Tammy, I've been in ministry long enough to know that this is not a good sign. It's not good to be put in a conference room. What are we going to do?"

"Let's wait and see what the doctor says and then we'll do what we have to do," she said.

The door opened and the doctor, holding her clipboard, sat down in front of us and said, "We have good news and bad news. Which would you like first?"

"Give us the good news," I said.

"The good news is that you don't have cancer."

"Well that's wonderful! But if that is the **good** news, what can possibly be bad news?" I asked.

"The bad news is that the Cologuard wasn't accurate and those of us in the medical field are

hoping that it will be more accurate in detecting cancer," she said.

"I don't really give a shit what the medical field is hoping for," I thought. Instead, I said, "I'm grateful for the good news. We need to celebrate! Do you have any champagne around here? If not, you should."

Rather than a celebratory toast, the three of us went to lunch. Joyous relief over the good news mixed with the hours-long prep beginning the night before make me one hungry and tired woman. I even decided to forego my vegan diet and ordered chicken and wild rice soup which was worthy of a Michelin star.

# CHAPTER 26
# Ashes

\*\*\*\*\*\*

*[love] brings you glory, brings you shame…*

**Andrew Lloyd Webber**
*Love Changes Everything*

\*\*\*\*\*\*

When Bob and I moved to Dallas we began an Easter family tradition that included a weekend of competitive games of bowling, coloring eggs while adults drink mimosas or Bloody Marys, licking our fingers during barbeque dinner prepared by Pitmaster Rich, belting out Easter Alleluias from dawn to dusk, and hunting and re-hunting those Easter eggs. Since tradition would pull us together in a few weeks, I decided Good

Friday would be an appropriate time to inurn Bob's ashes.

I'd like to say that Bob and I thoroughly considered the theological, ecological, and biblical reasons for choosing cremation. Instead, our ponderings took place over a series of conversations that occurred after one or the other of us had officiated at an inurnment service. We agreed that we liked the newer trend of cremation for its simplicity and correlation to church cemeteries of old. Our final decision was made when I came home from work one evening and said, "PHPC is going to increase the cost of niches in a couple of weeks." He replied, "Well then, let's buy one now." We selected our niche and were at peace about our decision.

Unlike my grandmother, I am not a grave or columbarium visitor. I prefer holy gazing at photographs on my bedside table. In 2009, however, Alice and I met at a cemetery in San Angelo, Texas, where our parents are buried. The emotional impact of seeing them side by side caught me by surprise. I was grateful that through all hardships that could have separated them they were together. After we placed fresh wreaths of

pine with cones and berries on the tombstones, I walked away with a change of heart.

I shared this visceral experience with Bob. "I want you to know that I'm fine with you being buried next to Barbara in Austin. After seeing my mom and dad together I believe it would mean so much to Tammy and Jim." Bob silently absorbed my thoughts and asked, "Are you sure?"

"Yes. Will you tell them?"

Months later, after officiating at an inurnment service, I rushed home and burst into tears telling Bob, "I can't do it. I can't do it. I take back my offer. I want at least part of you inurned with me."

He kissed my tears, caressed me by strolling his fingers through my hair and said, "Of course, of course. That's the thing to do."

On Good Friday, 2018, the urn held one-half of Bob's ashes. I'd asked Rich, Diane, Robert and Ken to place the urn in the niche. Bob dearly loved each of them and they had been backstage or like supporting actors in our initial and raw grief so I wanted them to have a role in the service.

It was more people than were actually needed; however, earlier in the week, a director at the funeral home told me repeatedly, "Your

husband's cremains are so heavy. Wow! They are so heavy. They may be the heaviest ones I have ever held. Here hold them. What do you think? Did you know that he had such heavy bones?" Those of us who have experienced the death of a loved one will testify that people say and/or ask the most outlandish things. These comments from the funeral home director qualify to be listed in *"The Top 100 Sayings that Make Mourners Moan."*

APTS President Ted Wardlaw reached out to me to schedule a memorial service for Bob on the seminary campus in early May for administrators, faculty and students who were unable to travel to Dallas. He invited me to speak and to select the preacher. I was hesitant about speaking and quick to name the preacher — Dr. Lewie Donelson.

Lewie was my choice because when Bob and I had come to a fork in the road of our dating relationship, it was Lewie to whom Bob had turned for counsel. Lewie listened with the heart of a friend and spoke with the wisdom of Solomon, "Bob, with love there is both joy and sorrow." Thankfully, when Bob was sorrowing because as he had put it to me, "I realize that you are not perfect and I wanted you to be," Lewie's words spoke truth to Bob.

My hesitation about speaking was eased when Dr. Scott Black-Johnston agreed to write some of his reflections so that I could read them and Dr. Michael Jinkins called to say that he wanted to speak at Bob's service. Scott and Michael are former APTS faculty members (hired while Bob was Academic Dean), respecters of Bob's decades of loyalty to the Chicago Cubs, Tennessee Volunteers, and admirers of his classy collection of braces that was his signature attire.

We planned to inurn the other half of Bob's ashes next to Barbara's grave after the service at the seminary in The Shelton Chapel (named after Bob at his retirement in 2002). As family made travel plans to Austin, I decided to extend my trip over several days. First, I would spend a night with my Aunt Margie in Waco, then enjoy lunch with friends in Georgetown, dabble in watercolors with my cousin, Marjorie Rose, at a Laguna Gloria workshop, and keep heading south to spend a couple of nights with friends along the Comal River in New Braunfels. I hadn't ever taken a vacay like this and it was actually a tad stressful to pack all the different things I'd need over the course of those days and activities.

When I woke up at half past ten o'clock at my aunt's home, I thought I'd spun out of the earth's orbit to another planet or at the very least been taken over by the Russians. I had never, ever slept that late—not in all my born days! Still groggy, I was clear-headed enough to know that I needed to cancel the 11:30 lunch I had planned in Georgetown. Margie, kept insisting, "Franny (she's the only person who calls me this name) you **needed** that sleep. Honey, grief is exhausting."

After coffee, orange juice, fresh strawberries and more coffee, I resigned myself to the fact that a change in plans is not earth shattering. Margie asked, "Now what are all your plans?" After listing off my plans up to New Braunfels I said, "…and then we'll have the memorial service and go to the cemetery to inurn Bob's ashes."

Those words, "Bob's ashes," were just out of my mouth when I shot out of my chair and screamed, "No! No! Oh, my God. Oh, Margie."

"What? What?" she asked in the same wave of shock that I felt.

"Oh, no!" I cried as I paced frantically (no pun intended). "I **FORGOT** Bob's ashes!"

"Franny, nooooo. Noooo, you didn't."

"Yes, I did. Shit. I can't believe it. Oh, no! Margie, I've got to get going. I've got to drive back to Dallas and get Bob's ashes."

"Can't you call someone? Can't you call Tammy and ask her to bring them?" she asked.

"No!" I said. "I am not going to call Tammy and say, 'Oh, I forgot your Dad's ashes. Can you swing by the house and pick them up?' Plus I'm not exactly sure where they are. I think they are in my bedroom closet but they could be in the hall closet. I've got to go." In a jiffy I was on I-35 for the 90+ mile trip back to Dallas.

I did make sure that I remembered my retainer of teeth because at this point I had already misplaced them seventy times seven times. The problem was that I couldn't eat with the retainer in my mouth so I was always taking it out and placing it somewhere. Once when they were lost, I retraced my steps, driving like Danica Patrick and praying like Mother Teresa, to a Chipolte parking lot. I remembered taking the retainer out. I prayed that I had put them in my lap and hopped out of the car where they just possibly landed in the parking lot. There they were! In my heart, I heard Bob saying, "Fran, you're good at finding things because you've had so much experience."

## Chapter 27
## Words, Books & Bridge

******

*Books are good company, in sad times and happy times, for books are people – people who have managed to stay alive by hiding between the covers of a book.*

**E. B. White**

******

This year I have been sensitive to the power of words—from the sublime, as in *"the Word became flesh and dwelt among us,"* to the ridiculous, as in "Are you going to stay in your home?" After talking with my widow friends, the ridiculous words are too frequent.

If a *"Dictionary for People in Grief"* existed the word comfort would appear as follows:

**com fort /ˈkəmfərt/**

*Noun —*

1. As in proper and used with an illustration to let family members know that the deceased is thought of and missed by other people; research will soon reveal this is *the best form of comfort* and may be expressed verbally or in writing. Examples:

> "Once Bob said, 'Preaching is like throwing water across narrow necked bottles.'"

> "It was such fun to see Bob and you sitting next to each other in a booth, rather than across, at Taco Diner on Friday nights."

> "I knew you were in love with Bob by looking at the way you made his turkey sandwich."

2. Food that releases endorphins and producing stay-on fat such as baked potatoes, mashed potatoes, French fries, hash browns, potato bread (any kind or color of potato)

> *synonyms:* dark chocolate with almonds, caramels or both; cheese grits made by Barbara Pittenger

*Verb—*

1. Measures of assuage to the mental, social, physical and spiritual distress of grief. Examples:

> When you see a widow or widower sitting alone in church, ask if you could sit by them. It *comforts* the person.
>
> When bereaved individuals talk about feeling sad or guilty, *do not* attempt to talk them out of these feelings, LET THEM TALK!
>
> *antonym:* Fixin' (West Texas for fixing) the situation—YOU CAN'T! Empower bereaved by letting him/her figure it out—THEY CAN!

   1. Physical expressions of understanding the process of grief like smiles, hugs, fist bumps, nods of greeting, handwritten notes, and random text messages

   2. Silence that is not judgmental

Example: It *comforts* me to be with a friend and not feel like I have to talk.

*Antonym:* verbal one upping of experiences or feelings of grief

My Kindle is loaded with a variety of genres that I read while tangled up with Bob during the years of our sevenish o'clock bedtime. As long as I kept my left leg slung over or next to his right leg, he slept soundly and I felt more like a wife than a care partner.

I've read and re-read many books in order to keep up with the selections for my four book clubs —joy is in reading. These groups are a magnum opus portion of my social life.

The first is a small group committed to adding a cookbook to the reading list. Of course, the hostess is expected to prepare a savory dish from the cookbook in addition to reading the book. The group is passionate about environmental concerns and kindness.

Best reads this past year (in my opinion): *"The Taste of Country Cooking"* by Edna Lewis

*"Destiny of the Republic: A Tale of Madness, Medicine and the Murder of a President"* by Candice Millard
(I wish high school history classes were taught with books like this.)

Another club is made up of active and retired certified church educators. The commitment to the group is equal to the above group—a member arrives via Southwest Airlines from Lubbock to attend. Since we simply can't or hardly can help it, we are known for getting ideas for Sunday school classes, sermon illustrations, or service projects out of our reads.

Best reads (still in my opinion):
*"Tattoos on the Heart: The Power of Boundless Compassion"* by Gregory Boyle
*"Holy Envy: Finding God in the Faith of Others"* by Barbara Brown Taylor

*The Literary Ladies* is composed of professional women of both Jewish and Christian faiths. We're eager to hear and learn about different and sometimes funny misunderstandings of our faith perspectives and traditions. All reads must be available in the public library, wines need to be at correct temperature (a pastime sommelier is in the group) and prizes are sometimes given.

Best reads:

*"Bobby Kennedy: A Raging Spirit"* by Chris Matthews

*"Where the Crawdads Sing"* by Delia Owens

(read in 3 of the 4 clubs)

Last, but far from least, is my Circle 11 book club—third Tuesdays September - May; 9 a.m.; coffee required; breakfast goodies optional; reading of the book strongly suggested but hey, we are into forgiveness. Over the last 15 months, five of us have experienced the death of our husbands, two died suddenly and three lost their strength and charm over a period of years.

After each death, a Basket of Comfort was given to us filled with items ranging from teas to books and chocolates (genuine comfort) to movie tickets. One item in my basket was *"Home Fire"* by Kamila Shamsie. Shamsie is a writer and artist who paints images with her choices of words. When my grandmother would hear such images, she would say, "I wish that I had said that! Never fear, I shall." I wish that I had painted these descriptions of grief:

> *grief saw nothing but itself, grief saw every speck of pain in the world;*

*grief spread its wings large like an eagle,
grief huddled small like a porcupine;
grief needed company, grief craved solitude;
grief wanted to remember, grief wanted to forget;
grief raged, grief whimpered;
grief made time compress and contract;
grief tasted like hunger, felt like numbness, sounded like silence...
grief was the deal God struck with the angel of death, who wanted an unpassable river to separate the living from the dead;
grief the bridge that would allow the dead to flit among the living, their footsteps overheard, their laughter around the corner,
their posture recognizable in the bodies of strangers you would follow down the street, willing them to never turn around.*

**Kamila Shamsie**

No need to say more, you get the idea.
"The Enchanted Life of Adam Hope" by Rhonda Riley
"Dear Committee Members" by Julie Schumacher (hilarious!)

"*Ordinary Light*" by Tracy K. Smith

In my grief, I've turned to the greatest escape and challenge—duplicate bridge, that never-ending brain-testing puzzle that helped bring Bob and me together. When there is not a sanctioned game, a foursome will take the trick. Bridge is a distant second cousin to love when the card counts are high and a kissin' cousin with the devil when most hands are Yarbroughs (not a single, solitary card higher than a ten).

I was slapped with a grief burst during one game when our opposing partners began talking about a friend who had Alzheimer's. They couldn't get over their dominant feeling of sadness and their sense of helplessness. Tears rivered down my cheeks; one looked at me and said, "Oh, you must know what we are talking about."

Speechless, my friend and partner, Barbara Pittenger, said, "Yes, she does. All too well."

That same evening, Kris and I enjoyed a dinner at *Edith's*, a French restaurant with the most delish sweet potato fries covered in Raclette cheese (forget them as a side dish, they are my main). All the way home we talked about what a great restaurant it is and how the wait staff are out-of-the-way personable. As I was pulling into the

garage and saw the empty space where my car parks, it reminded me, "Kris, I left my teeth at Edith's! We've got to go back." I called to warn the staff that some teeth were underneath the table where we had sat. Bless Kris' heart! She ran in to get them and they had placed them in a large take out box tied beautifully with a ribbon. Clearly, leaving my teeth at a French bistro was a step up from a Chipolte parking lot.

After my good news of being cancer free and grieving the deaths of too many loved ones, Omi, Sarah and I made a pact that we would be attentive to our health. Although I have not established a regular exercise program even though Tammy and Jim gave me, at my request, a membership at a fitness club and the red needle on the scales keeps moving to the right, I did make an appointment for my yearly physical.

The PA asked me about Bob and how I was faring. She was sympathetic when I explained that he had died. A bit later in the exam she asked, "Do you want a PAP smear?"

I laughed and said, "I don't think anybody ever really wants one but I know they are important."

"Well," she said, "You aren't going to have sex any more so you really don't need one."

Processing her remark about having sex is interesting. Sometimes I think it's funny. Then I wonder if I think it is funny because it's really sad and makes me miss Bob. Other times I'm struck by how presumptuous she was. I mean, on one hand I'm not planning to begin living a promiscuous life. On the other hand I wonder, "How does she know? How do I know?"

# Chapter 28
# A 17-Month Year

\*\*\*\*\*\*

*We are deemed worthy
by our sense of unworthiness.*

**My favorite quote by
Bob Shelton**

\*\*\*\*\*\*

Off into the world I have gone without Bob for over a year. If another person asks, "So since you are a bereavement specialist, has it helped you? Have you managed well?"

My replies, "Yes. No."

Yes, it has helped because I know that grief causes folks to do *"cruzzy"* things like forgetting important dates, times and items. Instead of letting this bother me, I just say, "I'm grieving."

No, I don't think I've done so well if I gauged myself by the standard, "you grieve the way you live." As Sarah explained to inquiring minds, "My Mom laughs a lot, cries a lot, and goes to bed early."

It is difficult to laugh when you are missing teeth. I even felt self-conscious when I would smile. And I have done some laughable, strange and marvelous things over the year. For a brief time I've toyed with being a vegan. I've let my hair go gray. I've started working several hours a week at *Paper Affair,* a gift shop where it was difficult to mark *"Single"* on the W-4. I've gone to two ballets (more new and uncommon for me than funny). I've run several red lights and I'm glad they've banned those silly ass cameras. I've found pictures of Bob when he was vibrant, sexy, and smiling. Thanksgiving was celebrated at Tammy's and Rich's home and I was ever so thankful for the twenty-three+ years Bob and I were married and for the families we joined together. The Tilton side of the family had Christmas in New York, including a carriage ride through Central Park and seats at Radio City Music Hall to see The Rockettes. I wrote a book.

My anxiety medicine blocks my capacity to cry so I have learned that grief is in direct proportion to visible tears. The only place where I can release measures of grief through tears is in church. The space is filled with Bob's spirit. The hymns remind me of Bob paraphrasing Martin Luther, "When teaching faith, give me a hymnal over a Bible." The prayers open crevices of my heart. The silence—healing. When taking communion, the imagination of my faith has me sitting by Bob. The community on earth and in heaven reminds me over and over again why I became Presbyterian.

I'll be reminded of Bob ad infinitum. Most of my writing has been done in our favorite room that looks out into our lush back yard. Faithfully, even as I'm pecking away this very moment, a robin sits watching me. Sometimes he is on the fence; other times he stands on the porch, as if waiting for me to let him in. He's *"perfectly"* comfortable in his own feathers and is willing for me to draw very near to snap photographs. There's no need to understand his visits or even attempt to explain them. Besides, like Bob would say, "If I understand, don't believe it."

I have shared with this bird that I'm often afraid since Bob died. Mostly I'm afraid that I will

not be able to learn anything new because I feel as if Bob taught me every wonderful thing that I know. And I'm uneasy when I make small purchases like buying a Starbuck's Cold Foam Cascara because I know Bob wouldn't order one. Making large purchases (like taking the swimming pool out of our back yard) never bothered Bob; however, he viewed some small purchases as being financially irresponsible. Thankfully, our love fills me with gratitude that trumps all my irrational fears.

Respect and appreciation for Bob's quick wit, ability to take the long view and his wisdom has grown since his death. If I was a betting person, I'd bet my life that after Bob moved to the group home, he thought, "If Fran's not going to take care of me, 'Lord, I'm Don Done'" which was his favorite spiritual.

Many a night, I'm still reading after 11 o'clock on Bob's side of the bed. The books are good but more so, I'm not sleepy. I wouldn't say that I've become a night owl, but I try to stay away from commitments before 11 a.m. I've made it a custom after turning off the light, to roll over and say (many times aloud), "Good night, Bob-Bob. I love you."

# Questions & Ponderings

## for your
### BOOKCLUB - SIRI THINKS ITS ONE WORD BOOK CLUB - OTHERS THINK IT IS TWO

**Tips—**
- Approach the time together as a way to get to know one another on a deeper and more intimate level by being vulnerable and sharing your experiences, reflections, and hopes.
- Practice grace—let members participate even if they have not read the book.
- Practice restraint—let members have their opinions (it's not about judging others and changing them; it's about accepting others, sharing life and learning).
- Refrain from asking right off the bat, "Who liked this book?" It tends to divide the group

rather than uniting members on a deeper level.
- Get started! I'll quit being bossy!
- Oh, wait! Feel free to invite Fran to participate with you hellofran@frantiltonshelton.com

**Questions & Ponderings—**

If we grieve the way we live, describe how you process grief and life. Are you a:
    talk-it-out person
    read-all-about-it/*Google* person
    silent-type
    pray, pray, pray
    hit-the-gym person
    other; combination

What is the difference to you between *privacy* and *secrecy?*

What causes you to worry? How do you respond to worriers?

Fran believes there are unwritten books inside each of us. What book is inside you waiting to be written?

What is a favorite Scripture verse or quote that you hold on to for courage or encouragement; peace; hope; or other needs?

Share about a special group of friends that you had at college, work or clubs. What do you appreciate and/or miss about them the most?

Describe a job or project that you were chosen to lead where you felt under qualified. What helped you through it? What did you learn from it?

Name one of your favorite teachers or professors and share what you still remember learning from him or her.

Which *Sheltonism* do you like? What about it causes you to like it?

If you have experienced a GIANT failure, what did you learn about yourself and others in that experience?

What is a turning point (personally or vocationally) in your life?

Describe the different points of view in a relationship where, *"It's not right. It's not wrong. It's just different."* applies.

How would you have dealt with Bob's request to not tell his children?

On a scale of 1 (really crappy) to 10 (woo hoo!), what score would you give yourself on the ability to ask for help? If you really want to practice, each of you ask a member of your group to help you with something---take you to the airport, go for a walk, run an errand.

So much of life is about timing. Describe a "timing" moment in your life that changed your life for the better.

Who would you desire to be near you at the time of your death?

Fran shared ways that she feels comforted after Bob's death (people sharing their fond memories of him with her and food). What brings you comfort?

Unexpected happenings cause pangs of grief. Share an experience you have had that surprised you with the recollection of a loved one.

What feeling(s) surface within you when you read the title *No Winter Lasts Forever  A Memoir of Loving Bob and Loathing Alzheimer's* ?

For a download version of these questions visit www.FranTiltonShelton.com.

To book Fran to speak, preach, teach or lead a congregation, conference, retreat or workshop, email hellofran@frantiltonshelton.com

Follow Fran on her social media sites at

www.facebook.com/AuthorFranShelton

www.pinterest.com/fratiltonshelton

## FRAN TILTON SHELTON

Fran is the matriarch of her blended family of four children and their spouses and five grand children. She's got courage to take deep finesses in duplicate bridge, stamina to be a member of four book clubs and a spirit for life that sparks contagious laughter.

Fran is one of the founders of Faith & Grief Ministries, a non-profit that provides communities, congregations and on-line bereavement resources. She facilitates bereavement workshops and spiritual retreats; preaches and teaches in congregations and at conferences.

For twenty years she served PC(USA) congregations in Texas, primarily in pastoral care. She is an Austin Presbyterian Theological Seminary graduate (MDiv 1993 and DMin 2007).

# No Spring Skips its Turn

## A Memoir of Loving Bob & Looking Forward

### Fran Tilton Shelton

# No Spring Skips Its Turn

*Why doesn't any person **tell** you that grief gets worse the second year?*

*Why isn't there a book that lets people know that **year two of grief is much more difficult than year one**?*

Exhausted with lingering sadness, bewildered and irritated participants in grief seminars facilitated by Fran Tilton Shelton would ask her such questions over and over again. With unique compassion and sensitive humor, she would respond, *"**Who** would want to be that person? And **who** would buy that book?"*

The visible stress each participant carried relaxed in the group's laughter that elicited renewed hope.

After Fran Tilton Shelton experienced the death of her husband, Bob, she accepted that although she didn't *want* to be, she was *that* person to write *that* book. Furthermore, although the question remains about *who* will buy the book, she feels Spirit-led to write about the increased difficulty of grief in year two in "*No Spring Skips Its Turn A Memoir of Loving Bob and Looking Forward*" scheduled to be released March 20, 2021, the first day of spring.

Made in the USA
Coppell, TX
03 May 2021